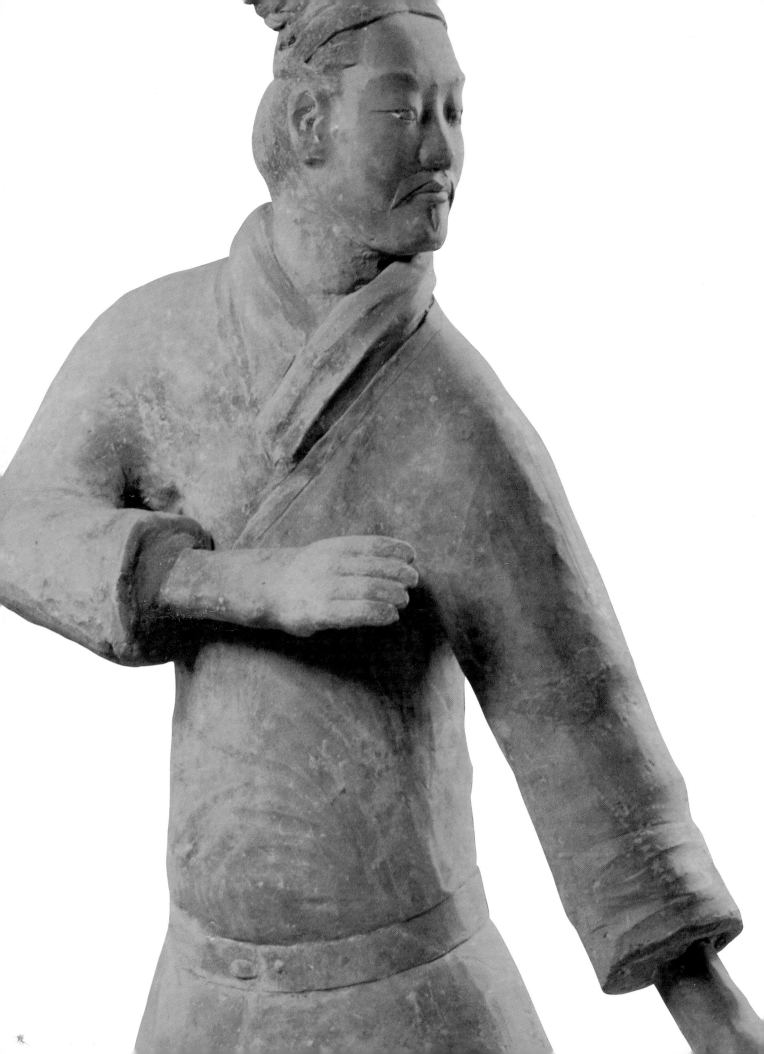

TOMB TREASURES
FROM
CHINA

THE BURIED ART
OF ANCIENT XI'AN

ASIAN ART MUSEUM OF SAN FRANCISCO

•

KIMBELL ART MUSEUM
FORT WORTH

Tomb Treasures from China: The Buried Art of Ancient Xi'an was published on the occasion of an exhibition organized by the Asian Art Museum of San Francisco and the Kimbell Art Museum with the cooperation of the Administrative Bureau of Museums and Archaeological Data (Cultural Relics Bureau) of the Shaanxi Provincial Government of the People's Republic of China. The exhibition traveled to three American venues as follows:

San Francisco, Calif.:
ASIAN ART MUSEUM OF SAN FRANCISCO
August 3 - October 30, 1994

Fort Worth, Tex.:
KIMBELL ART MUSEUM
November 20, 1994 - February 12, 1995

Honolulu, Hawaii:
HONOLULU ACADEMY OF THE ARTS
March 16 - June 18, 1995

This exhibition is supported by an indemnity from the Federal Council on the Arts and the Humanities.

Library of Congress Cataloging-in-Publication Data
Tomb treasures from China : the buried art of ancient Xi'an /
 [curated by Patricia Berger, Jennifer Randolph Casler].
 p. cm.
 "San Francisco, CA: Asian Art Museum of San Francisco,
August 3–October 30, 1994; Fort Worth, TX: Kimbell Art
Museum, November 20, 1994–February 12, 1995; Honolulu, HI:
Honolulu Academy of the Arts, March 16–June 18, 1995"—
T.p. verso.
 Includes bibliographical references.
 ISBN 0-912804-30-0 (paper)
 1. Art objects, Chinese—China—Sian—Exhibitions. 2. Art
objects, Chinese—Ch'in-Han dynasties, 221 B.C.–220 A.D.—
Exhibitions. 3. Art objects, Chinese—Three kingdoms-Sui
dynasty, 220–618—Exhibitions. 4. Art objects, Chinese—
T'ang-Five dynasties, 618–960—Exhibitions. I. Berger, Patricia
Ann. II. Casler, Jennifer Randolph, 1961– . III. Asian Art
Museum of San Francisco. IV. Kimbell Art Museum.
V. Honolulu Academy of Arts.
NK1069.S528T66 1994
709'.51'43—dc20 94-27657
 CIP
ISBN 0-912804-30-0

DONORS TO THE EXHIBITION IN SAN FRANCISCO

The Museum Society
The Bernard Osher Foundation
The William K. Bowes, Jr. Foundation
Charles Schwab & Co., Inc.
Air China
Columbia Foundation
Grants for the Arts of the San Francisco Hotel Tax Fund
Novell, Inc.
KGO NEWSTALK AM 810
KGO-TV Channel 7
Bechtel Foundation
Chevron Corporation
Citibank
Soong Ching Ling Foundation
Mr. and Mrs. M. Glenn Vinson, Jr.
Anonymous donors
Special thanks to the Honorable Frank M. Jordan,
 Mayor of San Francisco

FLYLEAF
Hollow Brick Decorated with Red Bird Design
Earthenware
WESTERN HAN DYNASTY (206 B.C.–A.D. 9)
Maoling Museum

FRONTISPIECE
Standing Archer
Terracotta
QIN DYNASTY (221-206 B.C.)
Museum of the Terracotta Army of Emperor Qin Shihuang

FOREWORD

From Rome and Istanbul and across the sands of time, the great Silk Road led to Xi'an. This capital of China, magnificent in its influence, resplendent with palaces and treasure, was first the seat of Qin Shihuangdi, the unifying First Emperor of China. Known then as Xianyang and later as Chang'an, the city profited from more than centralized political power. Its fortunate site was of windblown soil that retained moisture and produced abundant harvests when watered by canals started by the First Emperor's father. By record we know the city continued for centuries and became the richest on earth.

The First Emperor unified the written language, standardized weights and measurements (axle widths were fixed so that two carts abreast could pass on a road), created a monetary system, and fostered trade and commerce in the formation of a national economy. He walled his city and joined other scattered constructions to form what is now the Great Wall of China. The emperor's palace, with rooms 30 feet high and halls that could hold 100,000 people, was nearly 9,000,000 square feet in size and required hundreds of thousands of workers to complete.

Near Xi'an is Mt. Li. Beneath it is the Qin tomb. Visitors can see the mound rising over 225 feet in height. The tomb itself, which must be one of the wonders of the ancient world, has not yet yielded up its contents, but in March 1974, a farmer digging a well in an area about one mile from the great tumulus uncovered the first of the terracotta warriors, an army of the afterlife for Qin Shihuangdi. This incomparable find eventually revealed a battalion of soldiers in three groupings; the 7,000 figures, 100 chariots, and 600 horses, together with a large number of bronze weapons, present a spectacle for archaeology perhaps never to be repeated. The site covers 215,000 square feet.

The Asian Art Museum of San Francisco organized this exhibition with the Kimbell Art Museum in Fort Worth, Texas, to celebrate the twentieth anniversary of the find at Xi'an. While much more than the terracotta figures are represented here, it is clearly the warriors and horses that have captured the imagination of individuals all over the world. And rightly so, for the terracottas reveal in their modeling, structure, and size the grand scale of the ancient civilization at Xi'an. The imagination to produce life-size objects in such quantity, the ability to order the task, and the funds and determination to see the project through to completion rival any other physical accomplishment of a people. Perhaps only the pyramids and surrounding tombs of Egypt can finally compare.

In 1980 Dr. Emily Sano installed *The Great Bronze Age of China*, the first touring exhibition to include the terracotta warriors, at the Kimbell Art Museum. Now as Deputy Director, Chief Curator, and Chief Administrative Officer of the Asian Art Museum, she accepted the role of organizing curator for this exhibition, *Tomb Treasures from China: The Buried Art of Ancient Xi'an*, in order to demonstrate the glorious development of Chinese tomb arts forward 1,000 years, from the Qin dynasty, in the third century B.C., to the eighth-century Tang dynasty. Her successful negotiations with the Cultural Relics Bureau in the People's Republic of China resulted in an assembly of objects of the highest quality. We are deeply grateful to Mr. Song Zhenxing, Director, Overseas Exhibitions Department, Cultural Relics Bureau, Shaanxi province; Mr. Yuan Zhongyi, Director of the Museum of the Mausoleum of the First Emperor of Qin; and Mr. Chen Fangquan, Director of the Shaanxi Historical Museum, Xi'an, for their early support of the project, their many efforts on our behalf, and their generous consideration throughout.

Although it was initiated in San Francisco, the friendly cooperation of many individuals in China and the United States brought this exhibition to fruition. The President of the People's Republic of China, the Honorable Jiang Zemin, on a visit to the Asian Art Museum in 1993, endorsed the exhibition as an important event of cultural exchange. The Mayor of Shanghai, the Honorable Huang Ju, and the Mayor of San Francisco, the Honorable Frank Jordan, both lent their support for the show. The gracious assistance of consuls Mei Ping, Li Weile, and Zhao Liping of the Consulate General of the People's Republic of China in San Francisco was invaluable in all aspects of preparing the exhibition. To each, our profound thanks for their encouragement and help.

We are most pleased to welcome the participation of Director George Ellis and the staff of the Honolulu Academy of Art, Honolulu, Hawaii, as the final venue for *Tomb Treasures from China*. Finally, we wish to thank Mr. Ian Wilson, Chairman, Asian Art Commission; Mr. Johnson Bogart, Chairman, Asian Art Museum Foundation; and Mrs. Ben J. Fortson, President, Kimbell Art Foundation, and numerous other commissioners, trustees, donors, and friends for their enthusiastic support for the success of this project.

RAND CASTILE
Director
Asian Art Museum of San Francisco

EDMUND P. PILLSBURY
Director
Kimbell Art Museum

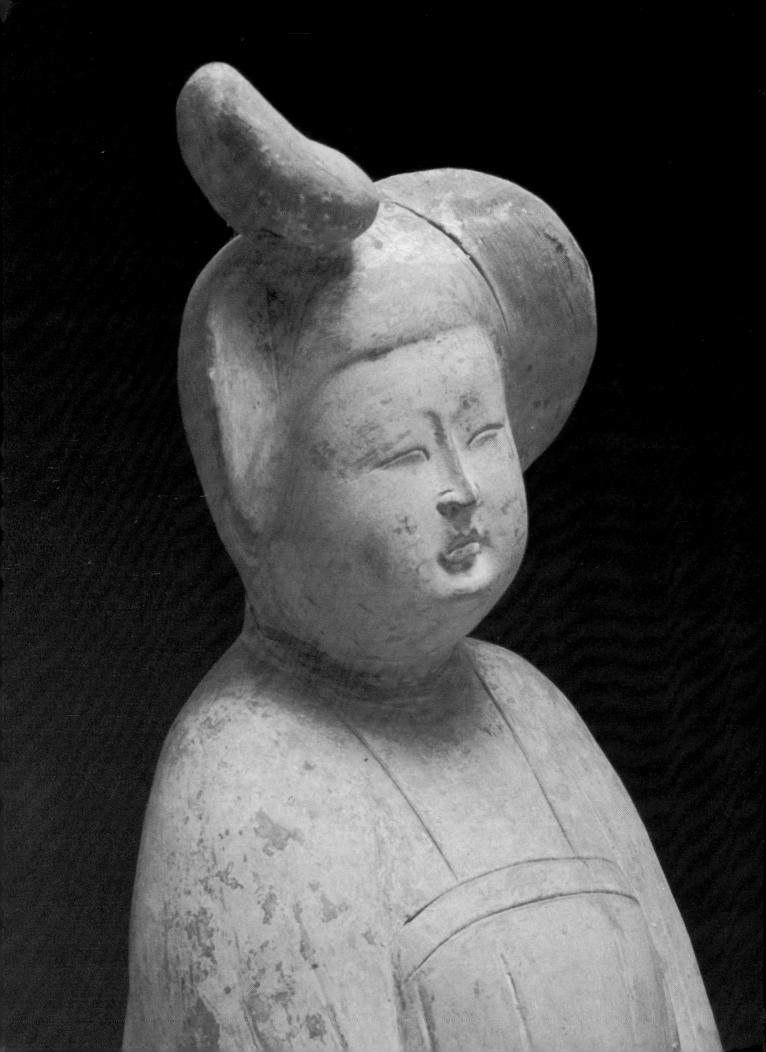

ACKNOWLEDGMENTS

The interest of the Asian Art Museum in an exhibition from China that focused attention on recent archaeological finds predates my own tenure on the staff by several years. In the case of the present exhibition, members of the Asian Art Commission and the trustees of the Asian Art Museum Foundation, recalling the tremendous success of the first great pre-normalization show from China in 1975, *Archaeological Treasures from the People's Republic of China*, and the 1983 exhibit *Treasures from the Shanghai Museum*, were eager to seek an exhibition that would bring the great terracotta warriors and horses from the tomb of the First Emperor to San Francisco for the first time.

As with many ventures, the success of this project was dependent upon a variety of circumstances and timing. My first visit to the Cultural Relics Bureau in Xi'an was in August 1993, with Ms. Terese Bartholomew, the Asian Art Museum's Chinese-speaking Curator of Indian and Himalayan Art, when we inquired about the possibility of an exhibition from Shaanxi province that could open in San Francisco just one year later, in August 1994. On a second trip, just three months later, with our dedicated Research Associate, Ms. Li He, and our intrepid Exhibitions Consultant, Mr. Hal Fischer, we were fortunate to capture the attention of the authorities in Xi'an at the Cultural Relics Bureau and the provincial museums, who acknowledged the possibility of accomplishing the show almost immediately, within a window of opportunity mutually available to both parties in 1994-95. We were pleased at that time to be joined in Xi'an by Dr. Edmund Pillsbury, Director of the Kimbell Art Museum, whose commitment to the project greatly assisted our cause.

The preparation of any exhibition requires the cooperation of a number of individuals, and the efforts of all departments of the Asian Art Museum, as well as the staff of the Kimbell Art Museum, to accomplish this project on short notice are commendable and deeply appreciated. At the Asian Art Museum, I was fortunate to have the talents of the Curator of Chinese Art, Dr. Patricia Berger, who co-curated the show with me. Dr. Berger wrote the principal essay for the catalogue, and she made many contributions to the realization of the show at the Asian. AAM Registrar Sharon Steckline managed the logistical arrangements for all three venues, as well as the application for a Federal Indemnity, and she supervised the packing of the objects in Beijing with Associate Conservator Katharine Untch. Throughout all our preparations, Li He handled our communications with our colleagues in the People's Republic with admirable patience and skill.

The Kimbell Art Museum contributed significantly to the project by publishing the catalogue, which was a remarkable joint effort on the part of several institutions. We are indebted to the Cultural Relics Bureau, Shaanxi province, for photographs taken by Qiu Ziyu and Gao Yuying and for information about the objects provided by Chen An'li, Li Suicheng, Yang Dongchen, and Shen Maosheng. The Kimbell Art Museum's Associate Curator for Asian and Non-Western Art, Jennifer R. Casler, wrote the catalogue entries, which were, in turn, edited in San Francisco by Michael Morrison of the AAM Education Department, Patricia Berger, and myself. Chinese texts were translated by AAM Docent, Dr. Doris Sze Chun, Jennifer R. Casler, and Chia Chun Shih, Librarian at the Kimbell Art Museum. The design and production of the catalogue are the skillful work of Tom Dawson in Fort Worth, Texas, designer for the Kimbell Art Museum.

I wish to thank all of these individuals for their tireless efforts, dedicated teamwork, and speed. They kept the faith and made this show happen.

EMILY J. SANO
Deputy Director, Chief Curator,
Chief Administrative Officer
Asian Art Museum of San Francisco

OPPOSITE: *Standing Lady,* earthenware with pinkish pigments, TANG DYNASTY (618-906), Cultural Relics Bureau, Xi'an

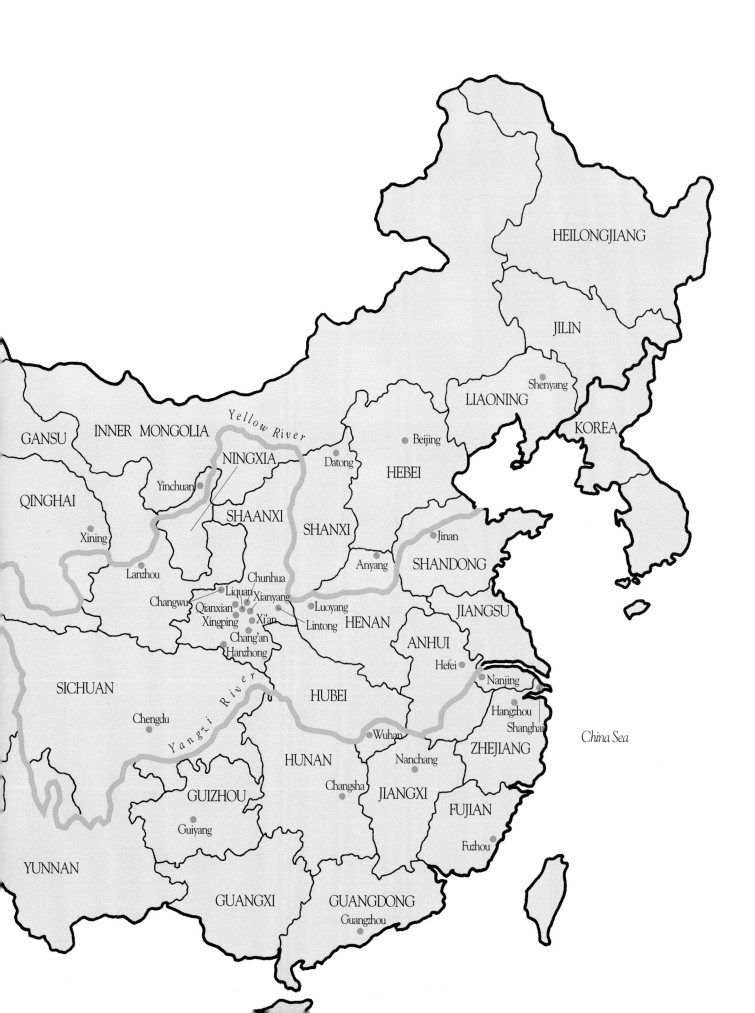

HEILONGJIANG

JILIN

Shenyang

LIAONING

KOREA

GANSU

INNER MONGOLIA

Yellow River

Beijing

NINGXIA

Datong

HEBEI

Yinchuan

QINGHAI

SHAANXI

SHANXI

Jinan

Xining

SHANDONG

Anyang

Lanzhou

Chunhua

Liquan

Xianyang

Changwu

Qianxian

Luoyang

JIANGSU

Xingping

Xi'an

Lintong

HENAN

Chang'an

Hanzhong

ANHUI

Hefei

SICHUAN

Nanjing

HUBEI

Hangzhou

Chengdu

Yangzi River

Shanghai

Wuhan

ZHEJIANG

China Sea

HUNAN

Nanchang

Changsha

JIANGXI

GUIZHOU

FUJIAN

Guiyang

Fuzhou

YUNNAN

GUANGXI

GUANGDONG

Guangzhou

CHRONOLOGY

Neolithic	ca. 8000-2000 B.C.
Xia	ca. 2000-1523 B.C.
Shang	1523-1028 B.C.
Zhou	1027-256 B.C.
Spring and Autumn	770-476 B.C.
Warring States	476-221 B.C.
Qin	221-206 B.C.
Western (Former) Han	206 B.C.-A.D. 9
Xin	9-23
Eastern (Later) Han	23-220
Three Kingdoms	220-265
Western Jin	265-316
Southern Dynasties	317-589
Northern Dynasties	386-581
Northern Wei	386-535
Eastern Wei	534-550
Western Wei	535-557
Northern Qi	550-577
Northern Zhou	557-581
Sui	581-618
Tang	618-906
Five Dynasties	906-960
Liao	907-1125
Northern Song	960-1127
Southern Song	1127-1279
Yuan	1279-1368
Ming	1368-1644
Qing	1644-1911
Republic	1911-1949
People's Republic of China	1949-

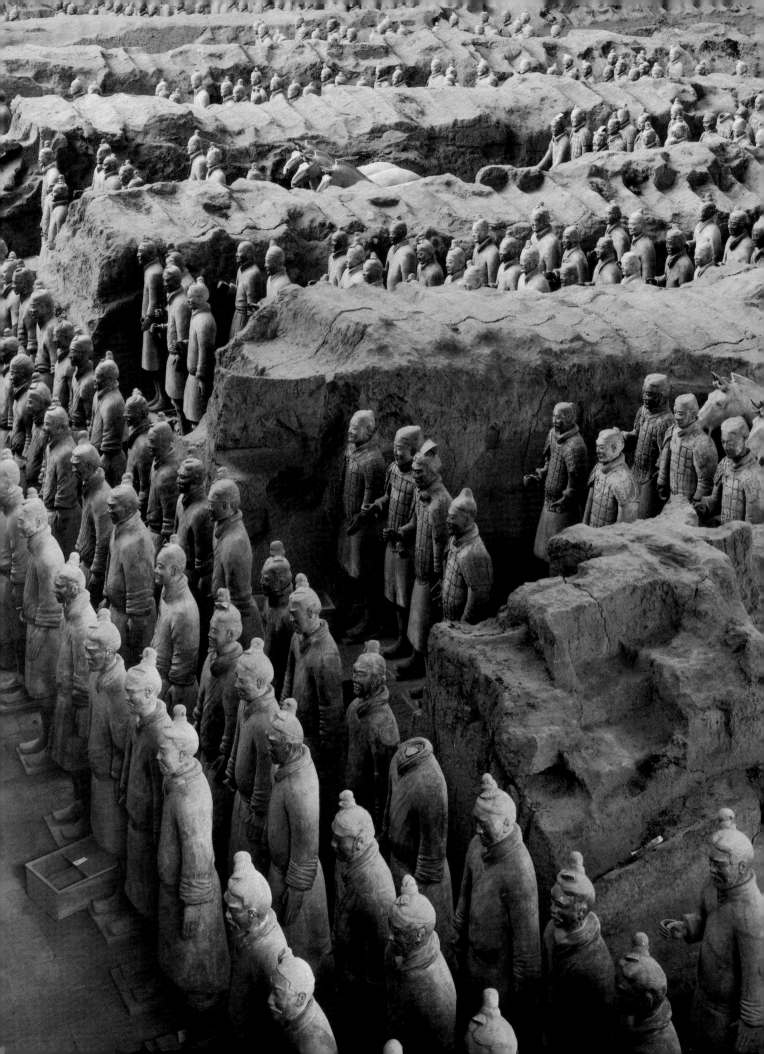

XI'AN—WESTERN PEACE

Xi'an, the city of Western Peace, set in a region blessed by fertility and strong natural defenses, was for centuries the "safest refuge of the empire."[1] In fact, southern Shaanxi province, where Xi'an is located, has attracted human settlement for over 6,000 years. The remains of Banpo, one of the earliest Neolithic towns in China, are a few kilometers beyond its modern boundaries, and the capitals of ancient dynasties, Zhou, Qin, Western Han, and Tang, lie beneath it and surround it. Shaanxi was the old homeland of the Zhou, who conquered the eastern-based Shang in the late eleventh century B.C. and created a dynasty that lasted, at least in name, for almost 900 years.

The Zhou built at least two capitals in the Xi'an region, Feng and Hao. Neither has been excavated (their hypothetical extents are indicated by the dotted lines on the plan below), but ancient records suggest that the plan the Zhou developed for their royal capitals was clearly designed to promote the status of the dynasty. The bare bones of this plan is preserved in the *Kaogongji* (Artisans Record), a chapter of the *Zhouli* (Rites of Zhou), probably compiled in the third-second century B.C.:

> The *jiangren* (artisan) constructs the state capitals. He makes a square nine *li* on each side; each side has three gates. Within the capital are nine north-south and nine east-west streets. The north-south streets are nine carriage tracks in width. On the left (facing south) is the Ancestral Temple, and to the right are the Altars of Soil and Grain. In the front is the Hall of Audience and behind the markets.[2]

This square plan, conceived as a microcosm of a square earth set within a round heaven, proclaimed the dynasty's fitness to rule the world by mirroring its shape and made it plain that Zhou had been granted the mandate of heaven, so eagerly sought by dynastic pretenders throughout Chinese history. The building and rebuilding of the capital in Zhou, Qin, Han, and Tang times followed the Zhou plan, repeating its idealized form as closely as possible, given the vagaries of terrain. The first-century poet Ban Gu's *Western Capital Rhapsody* describes the spiritual power of the rich, fertile land surrounding the Han capital at Chang'an (Eternal Peace), as Xi'an was called then:

> thrice it became the Imperial Domain.
> And from here Zhou rose like a dragon,

> And the Qin leered like a tiger.
> When it came time for the great Han to receive the
> mandate and establish their capital:
> Above, they perceived the Eastern Well's spiritual
> essence;
> Below, they found the site in harmony with the River
> Diagram's numinous signs.[3]

Shaanxi, and specifically Chang'an, remained the center of Chinese dynastic power for more than 1,600 years. Its position west of the narrow mountain passes that led east, poised near the confluence of the Wei and Yellow Rivers, gave the city a unique viewpoint. As early as the Western Han dynasty, perhaps well before, Chang'an became an entrepot between east and west, one terminus of the Silk Road that cut across Central Asia's forbidding deserts to Persia and Byzantium. This, as much as anything else, determined Chang'an's history and the tastes and mood of its popu-

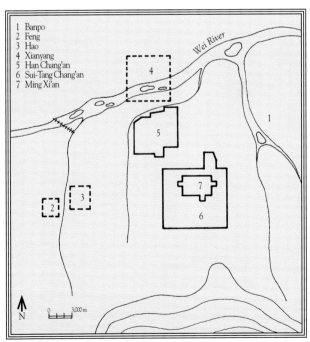

Xi'an through history. Reprinted from Nancy Shatzman Steinhardt, *Chinese Imperial City Planning*, p. 19

[1] From Ban Gu's *Western Capital Rhapsody*, in Xiao Tong, *Wen xuan* (Selections of Refined Literature), vol. 1, p. 101.
[2] Translation by Nancy Shatzman Steinhardt, *Chinese Imperial City Planning*, p. 33.
[3] From Xiao Tong, *Wen xuan*, p. 101.

OPPOSITE: Terracotta warriors in Pit No. 1, Museum of the Mausoleum of the First Emperor of Qin, Shaanxi Province
Photograph © by Don Hamilton

lation. Their craving for rare and exotic things, their openness to foreign ideas, especially during the Tang dynasty, distinguished them from their neighbors to the east.

The material remains of ancient China's culture excavated in Shaanxi in recent years have drastically amplified our view of early Chinese history, often verifying tales told in traditional records. This exhibition of some of the finest objects from Xi'an and its environs traces the history of China's imperial period from its beginnings in the Qin dynasty, after the fall of Zhou, through the great and glorious Tang, the last dynasty to choose the Xi'an region as the site for its capital. The historical remains found at Xi'an confirm it was there that the symbolism of the Chinese empire was created and refined and there that the style and tastes of its people were set.

THE FIRST EMPEROR OF CHINA

Reduced in scale to a small region around its eastern capital, Luoyang, the Zhou state was fragmented and exhausted by the third century B.C., the weakest of several contenders locked in a struggle to reunify China. The state of Qin controlled the old Zhou homeland along the Wei River; its capital was at Xianyang, north and slightly west of modern Xi'an. In 246 B.C. the king of Qin died, leaving the throne to his 13-year-old son, Zheng. Because of his tender age, Zheng began his reign under the watchful eye of a regent, the Qin chancellor Lu Buwei. The young king showed himself to be precocious, however. When he reached the age of 21, he removed Lu from office, objecting to his obstinacy and his rumored illicit relationship with the dowager queen, Zheng's mother. Zheng then set out on a path of conquest that ended in 221 B.C. with his annihilation of the last remaining independent state, his greatest rival, Qi. He was 38.

King Zheng of Qin showed himself to be just as adept at manipulating the symbolism of power as he had been at warfare. He began his new career by naming himself *huangdi*, a combination of epithets taken from China's legendary rulers, the three *huang*—august ones—and the five *di*—sovereigns. His full title, Qin Shihuangdi, is usually translated as First Emperor of the Qin, the first, as he saw it, in what would be a new, eternal dynasty, mandated by heaven.

Growing up during a period of philosophical debate, a time when "one hundred flowers bloomed," the First Emperor inclined toward legalism, which assumed men were flawed and prone to weakness, controllable only with an evenhanded, harsh system of laws and punishments. While his legalism silenced his opponents, often forcibly, it also resulted in consistency and increased efficiency. The First Emperor standardized weights and measures, currency, axle lengths, and the writing system, molding China's many regional cultures into a single, unified whole (cat. 10, 12). He undertook massive construction projects—roads and canals to link his vast empire and, his grandest project, the Great

Wall of China. Three hundred thousand conscripts worked on the wall to link fragments of earlier state walls into a continuous structure that stretched from Liaoning peninsula in the east to northwestern Gansu, a total length of nearly 2,500 kilometers.

Even if the First Emperor's political philosophy flew in the face of Zhou dynasty Confucianism, a system based on charismatic virtue, moral behavior, and homage for the past, his use of imperial symbolism suggests a lingering regard for the ancients and a healthy respect for his enemies. He expanded the Qin capital at Xianyang into a classical, Zhou-style plan, nearly square, with three gates to a side. On the north bank of the Wei, the original site of the predynastic Qin capital, he built replicas of the royal palaces of the states he had conquered on his way to the imperial throne. In the interests of verisimilitude, architects and carpenters were brought in from the original states to work on the palaces; they joined the more than 120,000 aristocratic families that had been resettled in Xianyang to separate them from their bases of power. This area of Xianyang, washed out by the Wei River and now high on a bluff, was excavated in 1974 and 1975. The rammed-earth foundations, drainage pipes, furnaces, wall murals, and decorated tiles (cat. 14, 15), however scanty, reveal an elegant, cosmopolitan life.

In 221 B.C., on the south bank of the Wei, linked to the old capital by a two-story covered bridge, the emperor began his own Ebang (or Afang) Palace, a multistory structure modeled on the palaces of Wen Wang and Wu Wang of Zhou, large enough, it was said, to host 100,000 men. The Ebang Palace was still not finished when the emperor died in 210 B.C., although his heir and successor, the short-lived Second Emperor (Qin Ershi), kept hundreds of thousands of workers on the job, even in the face of a peasant rebellion. In the Confucian dynasties that followed the Qin, the extravagance of this palace and its total destruction in a fire that blazed for three months as the Qin fell were still potent

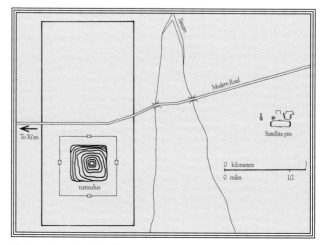

The burial complex of the First Emperor at Mt. Li. Reprinted from Arthur Cotterell, *The First Emperor of China*, p. 19

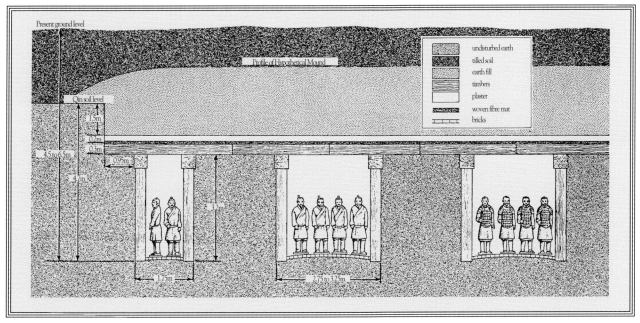

Cross-sectional views of three corridors in Pit No. 1 of the First Emperor's tomb complex. Reprinted from Arthur Cotterell, *The First Emperor of China*, p. 22

symbols of the First Emperor's abuse of power and of heaven's just retribution.

Intent on maintaining national unity and promoting the glory of his accomplishments, the First Emperor had a reason to be wary, both of his critics and of heaven. Seeking a kind of legitimacy legalism could not provide, he traveled relentlessly around his new empire and erected inscribed tablets on the peaks of China's sacred mountains, where he performed sacrifices in emulation of his Zhou predecessors. His fears grew even as his projects multiplied. When in Xianyang, for example, he slept in a different palace every night to avoid assassination. He consulted magicians and Daoist adepts on ways to prolong his life, supported their efforts to find the elixir of immortality and their search for the Penglai, Isle of the Immortals, which lay, they claimed, somewhere off China's northeast coast. But on one of his inspection tours to coastal Shandong, the First Emperor dreamed that his way to the Immortals' Isle was blocked by an immense fish, which, upon awakening, he hunted and killed. A few days after his harrowing premonition, however, he died at the age of 49. Hoping to manipulate the succession to the throne, the emperor's courtiers kept his death a secret. They hauled his body back to Xianyang in a cart filled with rotting fish to mask the odor of his decaying flesh.

The First Emperor had begun preparation for his death—or his eternal life—shortly after ascending the throne. Conscripts worked on his funerary complex at Mt. Li, conceived as an integral, if distant, part of the Qin capital, for over 30 years; it was still not complete when the emperor died. The Western Han historian Sima Qian (ca. 145-74 B.C.) described it a century later in

his *Shiji* (Historical Records) as a reflection of the imperial palace city (it originally had an inner and outer wall) and a mirror of the cosmos:

As soon as the First Emperor ascended the throne, work was begun at Mt. Li. After he had won the empire, more than 700,000 conscripts from all parts of the country worked on it. They dug through three underground streams and sealed them off with bronze to make the burial chamber. They filled the chamber with [models of] palaces, towers, and officials, as well as fine vessels and precious, rare things. Artisans were ordered to install automatically triggered crossbows to shoot grave robbers. The waterways of the empire, the Yangzi and Yellow Rivers, and even the great ocean were reproduced out of quicksilver, made to flow mechanically. The heavenly constellations were depicted above and the earth was laid out below. Lamps fueled with whale oil were placed to burn forever. The Second Emperor commanded that his father's childless wives follow him to the grave. After they were buried, an official suggested the artisans who had worked on the tomb's devices knew too much about what it contained. So, once the First Emperor was placed in the burial chamber and his treasures sealed up, the middle and outer gates were shut, trapping all those who worked on the tomb. No one came out. Finally, trees and grass were planted to make it look like a mountain.

Sima Qian's text might still be taken as extravagant hyperbole if not for the sensational discovery in 1974 of a pit about 1.5 kilometers east of the emperor's tumulus that proved ultimately to contain more than 6,000 life-size infantrymen, charioteers, and horses, all carefully crafted of earthenware, and originally covered with vibrant and realistic polychrome. Since that date, two more satellite pits have been unearthed; the second, 20 meters north of the first, is manned by standing archers, infantry, cavalry, kneeling crossbowmen, horses, and chariots—more than 1,300 figures in all (cat. 2-7). The third pit, a few meters farther north, holds 68 figures of high-ranking officers, the command center for the emperor's eternal bodyguard. All of these pits had been put to the torch, their wooden superstructures burned and collapsed, when the forces of Xiang Yu, a dynastic pretender at the fall of the Qin in the late third century B.C., invaded Xianyang. The tumulus of the First Emperor still awaits excavation—only that will prove or disprove Sima Qian's description—but anticipation mounts. In the winter of 1980, archaeologists opened a smaller pit at the base of the tumulus's western slope, where they found two half-life-size chariots, each complete with four horses, harnesses, and charioteers, fashioned exquisitely of bronze and decorated with polychrome.

In terms of sheer scale, the First Emperor's burial complex ranks as one of the most awe-inspiring archaeological discoveries of all time. It is also a precious record that preserves in grand and precise detail evidence of ancient Chinese attitudes toward death and the afterlife, which still prevailed many centuries later.

HAN CHANG'AN

The dynastic struggle against the First Emperor's corrupt second son and heir ended in 206 B.C. when the peasant leader Liu Bang "extracted the poisonous sting of fallen Qin"[4] and established the Han dynasty. Like his Qin predecessors, Liu Bang saw the advantage of keeping his capital near the site of Zhou and Qin glory, and so, in the wake of auspicious heavenly portents—a conjunction of the Five Planets (Jupiter, Mars, Saturn, Venus, and Mercury) and the Eastern Well (the constellation Gemini)—he raised Han's palaces on the ruins of Xianyang.

Han Chang'an is much less a phantom today than its earlier incarnations under Zhou and Qin. Built about two kilometers south of the Wei River, southeast of Xianyang and close to the First Emperor's Ebang Palace, the city has been the object of intensive study since the eleventh century. Detailed modern excavations of parts of the huge city site—its outer wall measured

25.9 kilometers—show that it deviated from the strong symmetry recommended by the city planners of Zhou, probably because of its siting near convenient sources of water and because its first palace, the Changle Gong, was built on the ruins of a Qin pleasure palace well before the outer wall rose. The Grand Historian Sima Qian explained Chang'an's lack of symmetry in cosmological terms, as an attempt on the part of the Han founders to have their capital mirror the Big and Little Dippers, but physical evidence does not bear this out. Even so, the Han clearly believed that heaven condoned the site of their capital, just as it mandated their assumption of imperial rule. Ban Gu's *Western Capital Rhapsody*, about A.D. 65, underscores Chang'an's eternal nature; the Han emperors, he wrote,

> planned a foundation of one million years . . .
> Each generation added ornament, exalted beauty,
> Through a long succession of twelve reigns.
> Thus, did they carry extravagance to its limit,
> lavishness to its extreme.[5]

Combined with classical histories and the rich finds of contemporary archaeology, the rhapsodic, opulently descriptive prose-poems (*fu*) of the Han provide a record of Chang'an during its heyday, in the vigorous early years of the Western Han. Zhang Heng's *Western Metropolis Rhapsody* (written ca. A.D. 90-100) confirms that walled Chang'an was at least half a palace-city, a fortress and residence for the imperial family. Using the typically high-flown language of the *fu*, he tells us that Han Wudi (r. 141-87 B.C.) built palace after palace, each one with "beams laced with intricate embroidery, / Embellished with vermeil and green, / Kingfisher plumes, fire-regulating pearls . . . / Gold pavement, jade stairways."[6] Like Zhang Heng's poem, Ban Gu's also evokes a sophisticated urban environment at the eastern terminus of the Silk Road, "pierced by roads and streets, with ward gates nearly a thousand,"[7] a city whose nine bustling markets offered up all the rare goods of the known world to a population of about one quarter of a million.

As capital of a vast empire, Chang'an was also a sacred center. Ritual structures—the Mingtang (Luminous Hall), the circular Biyong (Jade-Ring Moat), where candidates for imperial service studied, and the Lingtai (Platform of Condensed Essence)—occupied a complex within the outer city wall, but outside the palace compound. These buildings and the symbolic significance later Confucian writers attributed to them suggest that the Han emperors and the population they ruled viewed the world in far different terms from the ones by which we operate today. Despite

[4]*Ibid.*, p. 127.
[5]*Ibid.*, p. 103.
[6]*Ibid.*, p. 193.
[7]*Ibid.*, p. 105.

their conspicuous materialism, the Han saw heaven's hand in all worldly events. They found signs and portents in odd sports of nature and in the movement and conjunction of celestial bodies, which they could predict with astonishing precision. Thus, their histories are riddled with the ominous appearances of two-headed animals, comets, planetary conjunctions, eclipses, and with accidental discoveries of ancient artifacts of bronze and jade. It was in the regulation of the interaction between heaven, which manifested itself in omens, and earth that the emperor found his proper work.

This very Confucian view of the imperial role did not stop many of the emperors of the Western Han from seeking a different kind of solace in Daoism. Of all the rulers of the Han, Wudi was probably the most entranced with the possibility of eternal life. Like Qin Shihuangdi, he avidly financed the work of alchemists searching for the elixir of immortality and set up, according to Zhang Heng, "immortals' palms on high stalks / To receive pure dew from beyond the clouds . . . [and] pulverized carnelian stamens for his morning repast, / Certain that life could be prolonged."[8] His efforts in this direction knew no bounds. He and his Daoist adepts spent long nights on top of high watchtowers, hoping to spot and lure down plumed immortals (cat. 17, 33). He ordered sacrifices to the god of the hearth, thinking he might learn the secret of transforming cinnabar into gold. He also dispatched troops to Western Asia to find "dragon mounts" that could take to the air and carry him to the immortals' realms. This mission had a great practical benefit for the dynasty when the dragon mounts turned out to be the superior long-legged horses of Central Asian Ferghana. Crossbred with the indigenous tarpans of China, they formed the base stock of China's cavalry, which by Tang times topped 700,000 head.

Zhang Heng takes an ironic view of Han Wudi's preoccupation with his own immortality in his *Western Metropolis Rhapsody*, asking "if it were possible to live from generation to generation, / Why such urgent building of mausoleums?"[9] And, indeed, Han Wudi, like Qin Shihuangdi before him, had begun building his funerary complex, Maoling, in 139 B.C., one year after he took the throne. The Han imperial burial ground was an integral part of Chang'an's plan, built in the city's suburbs. Set within man-made pyramidal tumuli, five to the north and two to the south of town, the imperial burial complexes mimicked Chang'an's plan in microcosm. Here the Han, with their eyes cast on both sides of the great divide between this life and the next, settled potentially dissident lords and their clans from all around the empire and commanded them to make eternal offerings at the mausoleum towns.

This, according to Ban Gu, "was to strengthen the trunk and weaken the branches, / To exalt the Supreme Capital and show it off to the myriad states."[10]

We have little knowledge of the potential splendor of Han imperial burials; none of the imperial tumuli have so far been scientifically excavated. But excavations of less exalted burials have demonstrated the Han preoccupation with the afterlife and the intense interest they took in preparations for eternity; the most extraordinary of their efforts are the jade burial suits that have been found in some numbers, fitted shrouds of small jade plaques that were believed to preserve the body from corruption. Han Wudi had one carved, according to texts, with dragons, phoenixes, tortoises, and unicorns. In fact, the structure and contents of most Han tombs suggest that the next life was understood, as it had been in earlier dynasties, to be a kind of metaphysical transformation of this life, with the details of rank, marital status, family, wealth, and physiognomy transferred intact. Thus tombs were amply stocked with food, medicine, clothing, manuscripts, as well as surrogate attendants and guardians in clay and wood (cat. 19, 20, 26), and, by the end of the Western Han, with *mingqi* (bright objects), models of all the other necessities of life—livestock, barnyards, granaries, watchtowers, furniture, stoves, and pots and pans, all cleverly fashioned in glazed and unglazed earthenware (cat. 21, 22, 27, 28).

Many tombs, it seems, were designed to celebrate and memorialize the worldly reputation of the dead. For example, in 1965 an anonymous tomb was unearthed near Xianyang, between Changling, the imperial tumulus of the Han founder Gaozu (r. 206-195 B.C.), and Yangling, built for Jingdi (r. 157-141 B.C.). It had 11 satellite pits filled with small-scale figures, six of them with cavalry (more than 580 in all), and four with infantry (more than 1,800). There were also over 100 dancers and other attendants, all brought to the site to form a funerary procession for a person of high status. The military flavor of the assemblage (cat. 23-25) suggests it was made for one of the great generals of the early Western Han, perhaps Zhou Bo (d. 169 B.C.), a trumpeter and ritual singer who was elevated by Liu Bang to the rank of commander-in-chief of the armies of Han and appointed prime minister by Han Wendi (r. 180-157 B.C.). Zhou Yafu (d. 143 B.C.), Zhou Bo's adoptive son, also rose to the same high ranks after triumphant border campaigns against the Xiongnu. According to tradition, both were buried in the vicinity.

On an even more exalted level, Han Wudi's sister, the princess Yangxinchang, was buried with great pomp in a satellite to his own Maoling. Her tomb contained more than

[8]*Ibid.*, p. 201.
[9]*Ibid.*
[10]*Ibid.*, p. 109.

230 funerary gifts, including vessels of bronze, iron, lead, and lacquer, many with her family name, and a magnificent gilt bronze horse, the embodiment of Wudi's much wished-for dragon mount (cat. 16).

By the first century B.C., the Han court was corrupt and entangled in unproductive debates on the fine points of Confucianism. The dynasty was ripe for reform. A peripheral relative of the royal Liu clan, Wang Mang, took advantage of the situation to proclaim the new Xin dynasty in A.D. 9. He kept his capital at Chang'an, but rebuilt the ritual center south of the palace compound along idealized lines gleaned from the classics. His efforts only lasted a few years, however, for in A.D. 23, Han Guangwu retook the imperial throne and reestablished the dynasty at Luoyang, 350 kilometers east of Chang'an and north of the imperial estates in Henan province. While Chang'an remained a significant metropolis during the last two centuries of the dynasty, its exuberant style clashed with the stern austerities of the first Eastern Han emperors. Luoyang, one-third Chang'an's size, with double the population, was a much more serious place, a character it retained even in the Tang dynasty.

AFTER THE HAN

Chang'an was now eclipsed as a dynastic center, a situation that persisted for hundreds of years through the second half of the Han to the Three Kingdoms period and the period of Division between North and South (Nanbeichao), until the reunification of China under the Sui in 589. This is not to say that the city was ever abandoned, only that it began to lose its sheen. Archaeological remains provide the clearest evidence of life during this period. Burials uncovered in the Xi'an area, dating from the mid-Eastern Han (ca. 2nd century) through the Western Wei (535-557), reflect a well-to-do middle class deeply involved with the conservative values of Confucianism and concerned with their fate in the next life. Most common in the Eastern Han are tombs stocked with lead-glazed *mingqi* and decorated with stone engravings of watchtowers (cat. 29), scenes of homage, and palmlike trees holding aloft the Queen Mother of the West, Xiwangmu, whose ability to grant immortality made her the object of an important cult during the first and second centuries.

Chang'an fell first under the control of local, then foreign dynasties in the period of political fragmentation that followed the end of the Han. During the Turkic Northern Wei dynasty (386-535), for example, when the capital of northern China was first in Datong, far to the north, and later in Luoyang, after the Wei were more acculturated, Chang'an reflected rather than generated the trends and fads of the rest of the nation. People converted in increasing numbers to Buddhism, a foreign faith supported avidly by the Wei rulers, and commissioned steles recording their devotion, carved in the linear, fluttering style of the foreign

dynasty. Their graves, however, were stocked with earthenware attendants, often covered with lead-fluxed glazes that hark back to the Han (cat. 34-39).

SUI AND TANG
A RETURN TO GLORY

The founder of the Sui dynasty, Yang Jian, began his career as a general under the Northern Qi, a dynasty that reigned briefly in northeast China from 550 to 577. Yang married his daughter to the Northern Qi emperor, who had her assassinated to make way for a new favorite; the emperor, however, himself died shortly afterward. Yang Jian became regent, then, seizing his chance in 581, named himself emperor of Sui. It took him eight more years to conquer southern China and reunify the nation. Like Qin Shihuangdi before him, Yang Jian, now Sui Wendi (r. 581-600), took a pragmatic view of reunification. He shored up the Great Wall, which had failed to keep out the northern tribes; he built the Grand Canal, linking the south with Luoyang and Chang'an; and, as an avid Buddhist, he mandated a massive reconstruction of 4,000 Buddhist temples that had been damaged during the anti-Buddhist persecutions of the early sixth century. Like Qin Shihuangdi, he chose to raise his capital on the Wei River, but his magicians advised that old Han Chang'an, which had briefly served as the capital of the anti-Buddhist Northern Zhou and was the site of the assassination of the eight-year-old Northern Zhou heir apparent, was contaminated. And so Chang'an was rebuilt at the foot of Dragon Head Mountain (Longshou Shan), whose strong influences were balanced by digging Qujiang Pond to the southeast of town. Sui Chang'an rose complete on this new site in six months, designed once again to conform to the idealized city plan of the Zhou. Foursquare, with three gates to each side, it was divided into over 100 wards, created by nine grand avenues that ran north-south, and 12 roads that cut east-west.

In many ways, the Sui dynasty was an analogue of the earlier Qin. Sui, too, engaged in massive public works (accomplished, however, in an atmosphere of publically promoted Buddhism), unified the nation after a long period of division, and was, in the end, only a brief prologue to a much longer dynasty. When China was invaded by the Tujue Turks in the early seventh century, Sui's ablest general, Li Shimin, seized control and proclaimed a new dynasty, Tang, naming his father its first emperor. The Tang would reign for almost 300 years, one of the most glorious periods in Chinese history.

Following the example of the emperors of the Han, Li Shimin set out to create a vast, multinational empire based in Chang'an; he ultimately controlled a territory that stretched from Korea across Chinese Turkestan and to Vietnam in the south. Tang had ongoing formal relations with most of the nations of Asia; informally it welcomed guests from as far afield as Africa and

Indonesia (cat. 54). Chang'an itself, expanded after the fall of the Sui to include vast new palaces, was a magnet for foreign merchants who plied the Silk Road in long camel caravans. Most of Chang'an's foreigners were Western Asians; Canton, far to the south, received argosies from Arabia, Persia, and island Southeast Asia and shipped their rare goods northward.

Buddhism also brought foreigners to Chang'an, a city noted for its interest in exotic doctrines through much of the dynasty. Although the Tang emperors claimed descent from Laozi, the near-legendary founder of Daoism (which they publically espoused), many were ardent, doctrinally sophisticated Buddhists, who subsidized temples and translation projects in exchange for the protection of Buddhist deities in times of war. Chang'an tolerantly housed Manichaeans, Zoroastrians, and Nestorian Christians, all of whom were granted space to worship within the city walls.

At its height in the early eighth century, Chang'an was the largest city in the world, accommodating a diverse population of 2,000,000 in a space enclosed by a wall 35.5 kilometers long. The imperial palaces and administrative heart of the empire were built against the center of the north wall; the rest of the city was divided by the main avenue, Vermilion Bird Road, into two sectors, east and west. Of these, the western section was certainly the livelier, with a market that sold everything from Tangut horses to Tibetan parrots, busy tea houses, inns, wards reserved for foreign visitors, courts of law, and the public execution ground. The mood to the east, in contrast to this ongoing exuberance, was more discreet; it was the site of venerable Buddhist establishments, including the Great and Lesser Wild Goose Pagodas (Dayanta and Xiaoyanta), elegant mansions of the aristocracy, restaurants attended by "western houris," and costly brothels filled with talented, beautiful women.

In many ways, Chang'an was a Central Asian city, struck with a craze for exotica. By the end of the eighth century, the poet Yuan Zhen complained that

> Ever since the Western horsemen began raising smut
> and dust,
> Fur and fleece, rank and rancid, have filled Hsien
> [Chang'an] and Lo [Luoyang].
> Women make themselves Western matrons by the study of
> Western makeup;
> Entertainers present Western tunes, in their devotion to
> Western music.[11]

But Chang'an was also the place where the very Chinese arts of painting, calligraphy, and poetry thrived under imperial sponsorship, and where an ancient view of life after death prevailed, practiced on a scale as grand as ever.

As in the Qin and Han, the Tang built their imperial tombs northwest of Chang'an, in a form designed to evoke the city itself. Qianling, the tomb of the third Tang emperor Gaozong (r. 649-683) and his consort, Empress Wu Zetian (r. 690-705), is built into a natural mountain of grandiose scale, approached by means of a long avenue, the *shendao* spirit way, which reproduces the imperial path, *yudao*, of the capital. Qianling is still unexcavated, but it is surrounded by satellite tombs of imperial relatives constructed to expiate the sins of Wu Zetian as she made her bloody way to the imperial throne following her husbands' deaths. The empress Wu had been a concubine to Tang Taizong, later wife to his son Gaozong, until she finally usurped the imperial throne for herself in 690, claiming she was Maitreya, the Future Buddha. To accomplish this, she had several prospective heirs to the throne assassinated, as well as other prominent members of the imperial clan.

In fact, it was probably Wu Zetian's abdication and death in 705 that began a boom in the funerary industry in the early eighth century. Once the empress was out of the way, her victims, including the young princess Yongtai (d. 701), and the princes Zhanghuai (Li Xian, d. 684) and Yide (Li Zhongrun, d. 701), the heir apparent, were brought from their ignominious graves and reburied with great pomp (and some irony) close to the empress's own tomb in 706. All three of these satellites were excavated during the Cultural Revolution, each revealing a splendid tomb with a long, frescoed corridor leading to the burial chamber itself, hidden deep in the hillside. Prince Zhanghuai's tomb frescoes present him as a young man who loved hunting and polo (he was also an accomplished classical scholar); the heir apparent Yide's frescoes celebrate his position with an honor guard, shown outside the looming towers of Chang'an, the only clear visual record of the city's outer walls.

Along the sloped corridors, at regular intervals, are side chambers filled with earthenware burial figures, some painted, but most covered in *sancai* (three-color) lead-fluxed glazes (cat. 53). Like those found in numerous other Tang tombs (cat. 46-56), they reproduce everything the Tang found interesting, primarily the fine horses of Western Asia, but also camels; elegant, courtly attendants, musicians, and foreigners; *tianwang*, or heavenly guardians; earth spirits; animals of all sorts; fruits and vegetables; vessels to hold medicines, wine, and food; and even miniature mountain landscapes. So desirable were these burial sculptures, both glazed and unglazed, that the Brilliant Emperor, Minghuang (Xuanzong, r. 712-756), ordered that their use be strictly regulated according to rank. Thus officials above the third rank were entitled to 90 figures, those above the fifth to 60, and those above the ninth to 40. The *Tangshu* (Tang History) records that Minghuang's predecessor, Ruizong, had already deplored public displays of grave goods, which were carried in long processions

[11]Translation by Edward Schafer, *The Golden Peaches of Samarkand: A Study of T'ang Exotics*, p. 28.

from the capital to the tomb, sometimes stretching 10 kilometers. He complained:

> Lately nobles and officials have been competing with one another in the ostentation of their funerals. Figures of people and horses and carved ornaments are so lifelike that they draw the attention of passersby. This is not consistent with sincere mourning. If it is not stopped it will bring about even greater extravagance. It is my wish, therefore, that all those below the noble rank should follow the official regulations, and not display *mingqi* on the roadside, but only at the tomb.

Despite imperial objections to this ostentatious display of wealth, the Tang emperors' lives were no models of austerity or reserve. Minghuang's reign, the most glorious of the Tang, was distinguished by active patronage of poetry and the visual arts, and by the emperor's famous dalliance with his concubine, the exquisitely fat Yang Guifei. It ended tragically in 756 with the sedition and revolt of the young Central Asian Minghuang had adopted, An Lushan (Rokshan), who forced the emperor and his precious concubine on a long march of exile to Sichuan (Shu). Yang Guifei was assassinated en route, her body tied in a sack; the emperor continued alone to Shu.

It was probably at this time that Li Shouli, prince of Bin and son of Prince Zhanghuai, in fear of An Lushan, ordered that his collection of gold and silver, jade, gems, and rare medicines be placed in two large earthenware jars and one small vessel of silver and buried on the grounds of his palace. No doubt he meant to retrieve them, but they did not see the light of day until 1970, when they were unearthed from the same spot, now Hejia village, south of modern Xi'an. His collection represents all the glories of the Tang at its height (cat. 41-45). Its 270 perfectly preserved gold and silver artifacts, some from Western Asia, some Chinese, reflect the extravagant, eclectic tastes of a time when the Tang controlled one of the largest empires the world has ever seen.

After An Lushan's death, the Tang imperial family regrouped in Chang'an. The remaining century and a half of Tang rule were much more somber, however, and, in the end, less tolerant. In 845 an imperial decree purged China of all foreign faiths; the chief target was Buddhism, the ulterior motive to retrieve the tons of strategic metals used to make Buddhist images. The gesture was futile—Buddhist monasteries began rebuilding almost immediately and recovered in a few decades. But the writing was on the wall—the Tang was drawing to a close.

When the dynasty finally disintegrated in 906, the glory days of Chang'an also came to an end. The center of Chinese power had irrevocably shifted east of the passes, towards Kaifeng and ultimately Beijing, cities cast, like Chang'an, in the ancient pattern of Zhou.

PATRICIA BERGER
Curator of Chinese Art
Asian Art Museum of San Francisco

•Catalogue•

Jennifer R. Casler
Associate Curator
Asian and Non-Western Art
Kimbell Art Museum

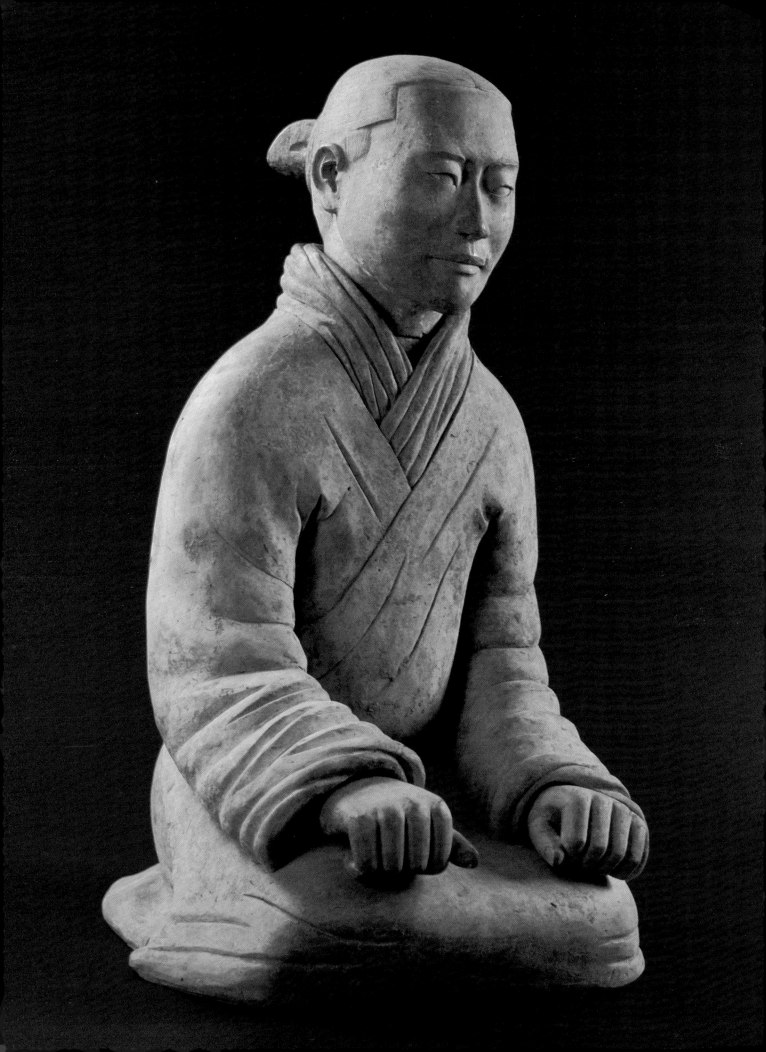

1

Kneeling Figure

Terracotta
QIN DYNASTY (221-206 B.C.)
H: 27⁹⁄₁₆ in. (70 cm)
Unearthed from the stable pits near the tomb of Qin Shihuang in
 Shangjiao village, Lintong, 1985
Museum of the Terracotta Army of Emperor Qin Shihuang

•

Kneeling figures representing stable administrators—
both masters and stableboys—were discovered east of Emperor Qin
Shihuang's tomb, near Shangjiao village, in a group of nearly 100
stable pits. Figures representing keepers of warhorses, exotic birds,
and livestock were unearthed from subsidiary pits.

This figure's attire, pose, and countenance indicate his
status as a court attendant, probably as a young groom in charge of
the stables. He wears a long-sleeved, belted robe folded to the right
and closed at the top with a thick scarf. Both arms are relaxed in
front, his hands resting on his knees. The hair is pulled back into a
simple bun and his facial expression is solemn and dignified.

Delicate and naturalistic rendering distinguishes this
sculpture from most Qin military figures. Though realistically con-
ceived, the officers and warriors often appear stiff and inert, whereas
the stable attendants have a softer, more lifelike quality.

2

General

Terracotta
QIN DYNASTY (221-206 B.C.)
H: 77³⁄₁₆ in. (196 cm)
Unearthed from the tomb of Qin Shihuang, pit no. 1, 1977
Museum of the Terracotta Army of Emperor Qin Shihuang

•

With his large, muscular frame, wide shoulders, and a
full, rounded waist, this imposing general from pit no. 1 of Emperor
Qin Shihuang's tomb stands upright, both legs planted firmly on a
square board. He wears a double-layered, long-sleeved robe under a
vest of "fish-scale" armor, decorative tassels on his upper chest, and
a scarf tied around the neck. His long pants are buckled tightly
around the ankles, above square-cut shoes that curve upward at the
toes. He has a long, bearded face with an alert but stern counte-
nance, and his hair is pulled back into an elaborate chignon which
includes an official cap with double tails that ties under the chin
into a bow. Both arms hang down at his sides, the left hand poised
as if holding a weapon.

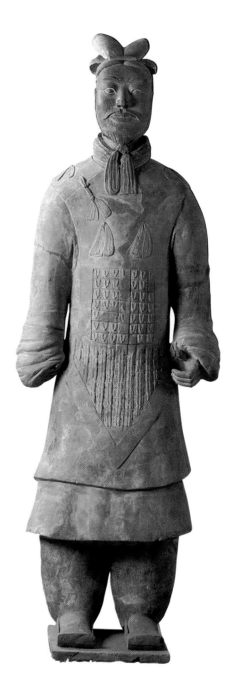

The largest of the three pits excavated to date, pit no. 1
contains an estimated 6,000-plus terracotta warriors and horses and
more than 40 chariots. The figures of the First Emperor's army
were realistically modeled with a fastidious attention to detail that
can be seen in their varied facial expressions, hairstyles, costumes,
and armor, all distinguishing attributes that identify different ranks
in the Qin army. Traces of pigment left on some figures indicate
that they originally had painted details that enhanced their lifelike,
individualized quality.

3

Cavalryman
Terracotta
QIN DYNASTY (221-206 B.C.)
H: 72⁷⁄₁₆ in. (184 cm)
Unearthed from the tomb of Qin Shihuang, pit no. 2, 1977
Museum of the Terracotta Army of Emperor Qin Shihuang

•

Leaner and livelier than the somber general (cat. 2), this handsome, mustachioed young cavalryman wears a narrow, knee-length coat, long, tight pants that narrow at the cuff, and stitched leather boots. A protective collar is folded securely to the right under a tight-fitting armored vest fastened with a leather belt. The vest, which covers the belly in front but ends above the hip in back, has no shoulder plates or sleeve armor, allowing his arms to move freely. The type of outfit seen here allowed cavalrymen both to mount the horse easily and to use the bow and arrow with precision while riding, which may account for the fact that cavalrymen 800 years later in the Tang dynasty wore similar costumes. His right hand holds the horse's reins, but the left hand is curved, as if holding a weapon, probably a bow or arrows common to the Qin army.

This cavalryman was unearthed from pit no. 2, which contains an estimated 1,300 warriors, horses, chariots, standing and kneeling archers, and infantrymen. The figures of cavalrymen are generally consistent in overall pose and detail.

4

Horse
Terracotta with traces of pigment
QIN DYNASTY (221-206 B.C.)
H: 68½ in. (174 cm) L: 83⅛ in. (213 cm)
Unearthed from the tomb of Qin Shihuang, pit no. 2, 1977
Museum of the Terracotta Army of Emperor Qin Shihuang

•

Originally painted a purplish red, this horse led by a cavalryman has a black square-cut mane, two-pronged forelock, and white hooves, and its long tail has been trimmed and plaited. The horse is not particularly large, but its torso is wide and its legs are sturdy and well developed.

The harness includes all of the equipment needed to control a horse—halter, mouthpiece, bridle, and saddle. Although the artist has incorporated some parts of a real bridle, the saddle is modeled directly in clay. The white saddle sits on a green saddle cloth and is decorated with eight rows of pink nails.

It is tightly secured to the horse's back by a girth strapped around his stomach, and a crupper, fastened to the back of the saddle, passes in a loop under the tail to prevent the harness from slipping. This type of saddle lacks stirrups and a martingale around the

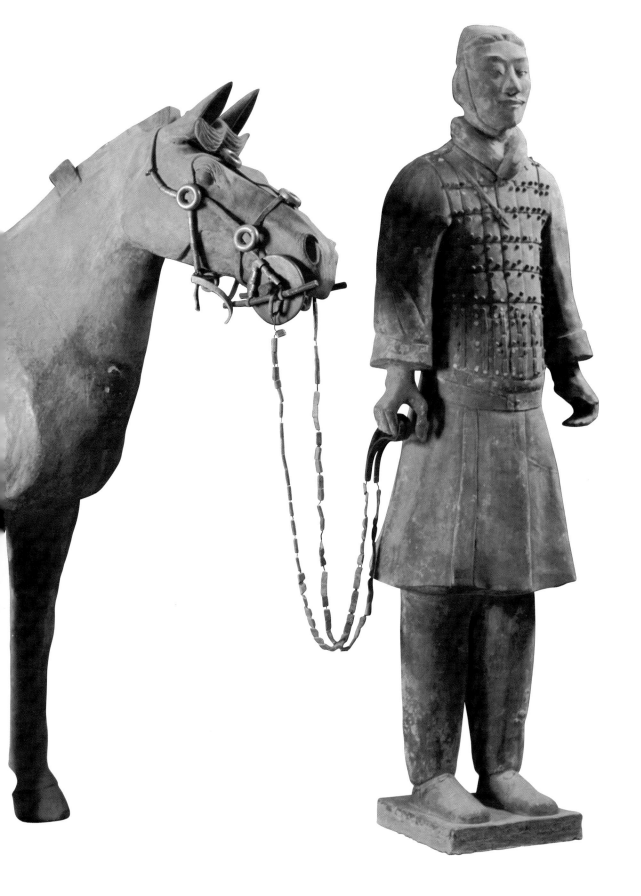

horse's chest, which indicates an early stage in the evolution of saddle design.

 Like the terracotta human figures, terracotta horses were constructed with legs of solid pottery supporting a hollow body and head. The horses' legs, heads, ears, manes, and tails were made separately and luted to the bodies before the firing process. The consistent shape of the legs suggests they were molded, then hand finished.

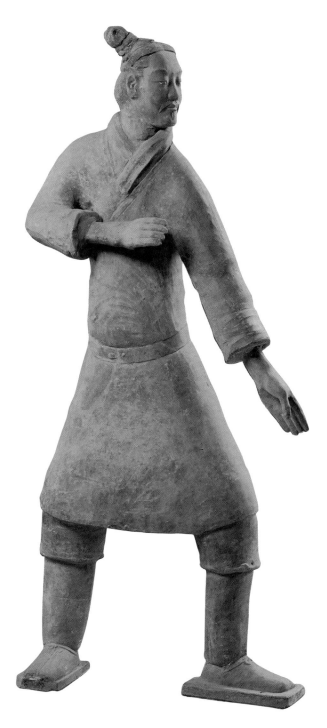

5

Standing Archer
Terracotta
QIN DYNASTY (221-206 B.C.)
H: 70¹⁄₁₆ in. (178 cm)
Unearthed from the tomb of Qin Shihuang, pit no. 2, 1977
Museum of the Terracotta Army of Emperor Qin Shihuang

•

This representation of a standing archer, with slim build, youthful visage, and alert expression, is one of the more animated of the terracotta warriors. The long, unarmored robe with a thick, folded collar folds over itself and is held in place by a belt and belthook. The archer wears short pants, which hang just below the knees, protective wrappings on his lower legs, and simple, flat shoes tied with laces. His hair is pulled up into a neatly coiled bun on the right side of the head. Poised for action, his feet are set apart with the right foot turned outward, the left knee slightly bent, and the left foot forward. The head and torso are also turned to the left. The right arm is bent, the fingers curled into a fist, and the out-stretched left arm is held stiffly with the fingers open and the palm facing the body. The hand gestures suggest he holds a weapon, but in fact his stance is the correct posture for holding a crossbow. Combative archery was well developed by the Qin dynasty, which established precedents for military practice that were followed centuries later.

6

Kneeling Archer
Terracotta
QIN DYNASTY (221-206 B.C.)
H: 46⁷⁄₁₆ in. (118 cm)
Unearthed from the tomb of Qin Shihuang, pit no. 2, 1977
Museum of the Terracotta Army of Emperor Qin Shihuang

•

Similar figures of kneeling archers, all recovered from pit no. 2, show slight variations in the details of their clothing. The straight and rigid pose of this kneeling archer corresponds to his expression of serious concentration. The battle robe he wears over short pants and double-wrapped protective leggings has a series of parallel pleats near the bottom, ending above the knee. A heavily armored vest with shoulder pads is fastened above his right breast with a V-shaped clasp. His hair is fashioned into an ornamental braid at the back of his head and then coiled into an elaborate bun tied with ribbons.

This archer is resting on the right knee with the left knee raised, his right arm at his side and his left arm positioned across his chest as if holding a crossbow and arrow. In a characteristic archer's pose, he kneels with his body turned slightly to the left, his head fixed, and his wide-open eyes staring to the left, creating a balanced triangle that allows him to focus and hit his target and minimizes his chances of injury from enemy weapons.

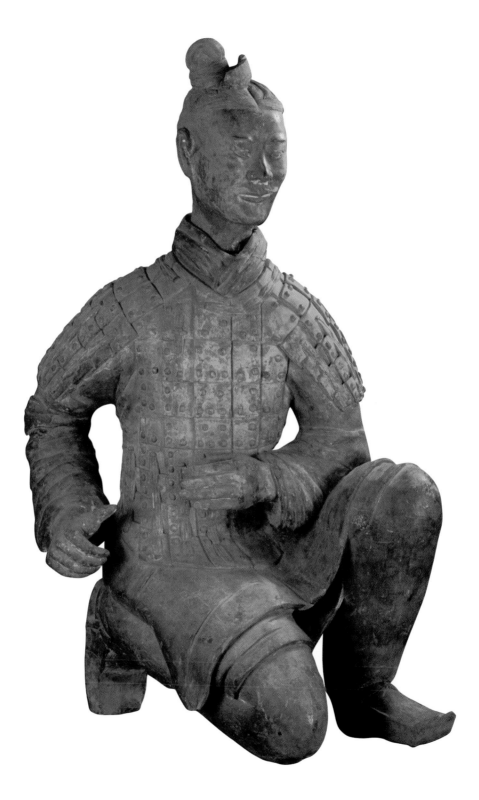

7

Officer
Terracotta
QIN DYNASTY (221-206 B.C.)
H: 73¼ in. (186 cm)
Unearthed from the tomb of Qin Shihuang, pit no. 1, 1980
Museum of the Terracotta Army of Emperor Qin Shihuang

•

Greater height and bulk distinguish officers in Qin Shihuang's army from other military personnel. This officer wears a battle uniform of short pants, boots tied at the knee, and full body armor including shoulder guards similar to the armor worn by the kneeling archer (cat. 6). His neck is protected by a thick scarf at the collar. The hair is pulled up into an elaborate cap tied under the chin in a double-tail bow, a smaller version of the cap worn by the officer (cat. 2). His solemn face sports a thin moustache and goatee. His right arm is poised at his side as if holding a shield, and his left arm is bent as if holding a weapon, perhaps a spear.

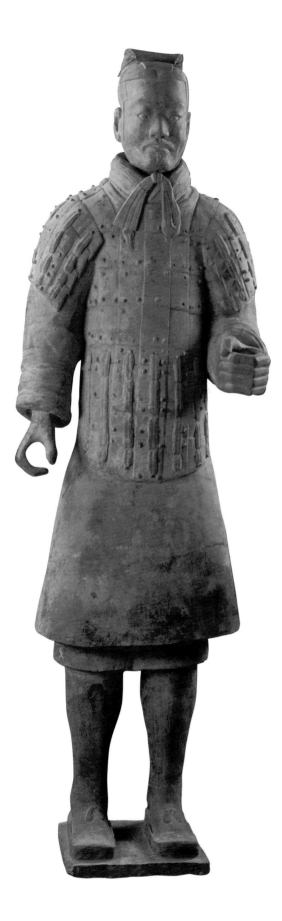

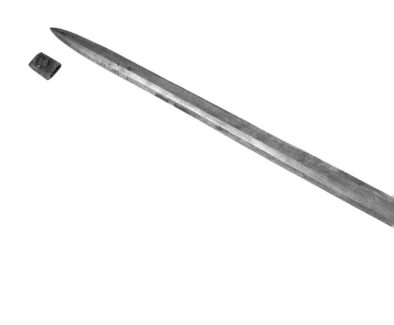

8

Arrowheads (10)
Bronze
QIN DYNASTY (221-206 B.C.)
L: 3³/₁₆ in. (9.1 cm) -7⁷/₁₆ (19.1 cm)
Unearthed from the tomb of Qin Shihuang, pit no. 1, 1976
Museum of the Terracotta Army of Emperor Qin Shihuang

•

 In addition to the terracotta figures of warriors and horses, the three pits contained quantities of bronze weapons and related military equipment since each figure was buried with a genuine weapon. The range of weapons includes the dagger-axe, spearhead, halberd, sword, arrowhead, and crossbow mechanism. The arrowheads featured here were used for long-distance shooting.

 The bronze used in these arrowheads is composed of copper and tin with small amounts of lead and zinc. The arrow is constructed with two metal parts: the sharp, pointed head and the tubular arrow shaft which attaches to the wooden or bamboo rod. The triangular head was cast separately from the shaft and then the two were joined together. The bamboo rod was wrapped in a coarse hemp cloth and inserted into the metal shaft, leaving only the arrowhead exposed. About 13 centimeters from the arrowhead, feathers were attached symmetrically on two sides of the rod to maintain the balance of the arrow as it flew through the air. The surface of the arrowhead was coated with a layer of chromium oxide to provide extra hardness and durability.

9

Sword
Bronze
QIN DYNASTY (221-206 B.C.)
L: 35⅝ in. (90.5 cm)
Unearthed from the tomb of Qin Shihuang, pit no. 1, 1988
Museum of the Terracotta Army of Emperor Qin Shihuang

 Qin soldiers used swords and curved knives for self-defense and close-range combat. In style and appearance this sword resembles the classic Zhou dynasty sword, which continued to be used in the Qin dynasty and into the succeeding Han dynasty. The hilt and blade were cast in one piece, then filed and polished smooth. The hilt has a rounded pommel and pyramidal hand cup and would have originally had a binding to ensure a safe grip. The sharp, pointed sword blade is narrow and thin with ridge lines running the length of each flat side. The blade of the sword has been embellished with gilding. Many bronze swords of this type had added ornamentation—generally turquoise, gold and silver, or jade inlay—at the guard and on the top surface of the pommel.

 All of the weapons unearthed from Qin Shihuang's tomb display advanced technology in composing alloys, casting, and processing. Weapons issued to the Qin military were the first to be standardized.

10

Weight

Bronze

QIN DYNASTY (221-206 B.C.)

H: 3⅞ in. (9.9 cm) Diam.: 5 in. (12.7 cm)

Unearthed from Qiaojia village, Shuizhen, Hua county, 1991

Xi'an Beilin (Forest of Stone Tablets) Museum

•

Among the First Emperor's reforms was the standardization of weights and measures. Composed of a bronze shell filled with lead, this hemispherical weight weighs one *jun*, or 7,650 grams (just over 16 pounds), and has a pierced knob at the top for lifting.

Two imperial edicts engraved in fifteen lines on the surface of the weight form the complete texts of the standardization decrees issued by Qin Shihuang and his successor, the Second Emperor Qin Ershi. The characters of the first seven lines, which are slightly bigger than the remaining eight, are an imperial edict of Qin Shihuang, issued after he declared himself the First Emperor in 221 B.C. It reads:

> In the 26th year of his reign, Qin Shihuang achieved the unification of states under heaven and brought tranquility to the people. He then assumed the title of emperor and ordered his prime ministers, Wei Zhuang and Wang Wan, to standardize all weights and measures that were not uniform or were in any way ambiguous.

The next eight lines, the second imperial decree, were inscribed in 209 B.C., the year the son of Qin Shihuang ascended the throne. They read:

> In the first year of his reign, the emperor summoned prime minister Li Si to eliminate inconsistency and proclaim standardization. These were the instructions of the First Emperor and had all been documented. Nowadays, in writing, people no longer follow the standardization of the First Emperor. This deterioration is caused by the passage of time. If in the future this trend continues the great achievement of the First Emperor will not be followed. Therefore, this decree is issued and engraved on the left to dispel any doubt.[1]

[1] Edmund Capon, *Qin Shihuang Terracotta Warriors and Horses*, p. 84.

11

Architectural Fitting with Coiled Serpent Pattern
Bronze
QIN STATE OF THE SPRING AND AUTUMN PERIOD (770-476 B.C.)
L: 22¼ in. (56.5 cm) W: 13³⁄₁₆ in. (33.5 cm)
Unearthed from Yaojiagang, Fengxiang county,
 Shaanxi province, 1973
Shaanxi Historical Museum

•

Sixty-four bronze architectural fittings dating to the
Spring and Autumn period were excavated in 1973-74 from three
cellars of a predynastic Qin palace compound at Yaojiagang in
Fengxiang county, Shaanxi province. Most pieces are hollow
rectangular or L-shaped sections into which wooden beams were
fitted. In spite of their age, their condition is very good, revealing
surfaces decorated with a beautifully arranged coiled serpent
pattern and ends finished in a sawtooth design.

Once bronze technology was well developed, wooden
architectural frames were often fastened with bronze fittings in
order to increase their strength. As a mortise-and-tenon system
replaced the use of metal fittings for strengthening the architectural
structure, the fittings became increasingly decorative, until they
were finally reduced to a purely ornamental, flat piece of metal.

The fittings unearthed from Fengxiang are clearly
decorative pieces. The similarity between the coiled serpent
patterns found on the frames and on predynastic Qin ritual vessels
of the Spring and Autumn period, as well as their discovery within
the imperial compound in the Qin city of Yong during the Spring
and Autumn period, suggests that these fittings were manufactured
during that period. The discovery of these architectural fittings is
very important in the study of Chinese architectural history since
they bridge the gap between the early fastening technique used to
secure the wooden joints and the later mortise-and-tenon system.

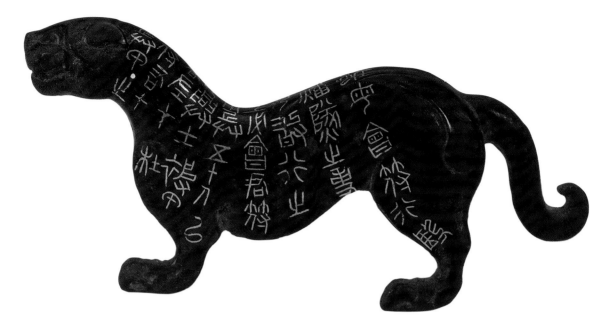

12

Tiger-shaped Tally with Inscription
Bronze
QIN STATE OF THE WARRING STATES PERIOD (476-221 B.C.)
L: 3¼ in. (9.5 cm) H: 1¹¹⁄₁₆ in. (4.4 cm)
Unearthed from Menkouxiang in the southern suburb
 of Xi'an, 1973
Shaanxi Historical Museum

•

This bronze tally, fashioned into the image of a tiger and inscribed with gold inlay, is a token used by the emperor to confer military power upon his ministers. It is constructed in two pieces. Only when both parts are fitted together, completing the inscription, would an officer accept the written orders as valid. The 40 character inscription, written in nine vertical lines, reads

A tiger tally for [commanding] the military force [is separated] with the right half held by the general [at headquarters] while the left half is given to the commander [at the forward command post.] When in charge of 50 armored troops or more, the commander must get the other half of the tally from the general in order to have the authority to issue and execute his orders. [The affairs of smaller-scale] forces may proceed without using a tally.

13

Mirror with Coiled Hornless Dragon (CHI)
and Lozenge Pattern
Bronze
QIN DYNASTY (221-206 B.C.)
Diam.: 8¹⁵⁄₁₆ in. (22.8 cm)
Unearthed from a Qin tomb in Nanping village, Qinhexiang,
 Chunhua county, 1980
Chunhua Cultural Museum

•

In ancient China, mirrors were used not only as functional articles in daily life but as sacred objects filled with a power of their own. The custom of placing mirrors in the tomb originated around the fourth century B.C., where they functioned as reflectors of the spirit world. Because mirrors reflect images and light, the Qin believed they had the ability to radiate light, and thus illuminate the tomb, for eternity. Often more than one mirror was placed in the tomb, not with the other funerary objects, but near the corpse—to the side of the head, on the body, or inside the coffin.

The hemispherical boss in the center of the mirror once had a braided silk cord threaded through the transverse opening from which to suspend the mirror. The central field of the mirror is decorated with a pattern of four coiled hornless dragons stylized to read as geometric motifs positioned between four zigzag lozenges on a background of spirals in low relief.

The development of mirror decoration over the course of time reveals the evolution of ideas and beliefs in China. Many of the signs used on mirrors symbolize cosmic powers manifested in the change of seasons, the constellations, or auspicious emblems (cat. 40 and 58). The dragon was believed to embody the essence of the *yang*, or male, principle and symbolized the spring season and renewal. Coiled dragon patterns of the type seen on this mirror were common on bronze vessels from the Spring and Autumn period (770-476 B.C.). By the mid- to late Warring States period (476-221 B.C.) the design began to appear on bronze mirrors and continued to be popular throughout the Qin and early Han dynasties.

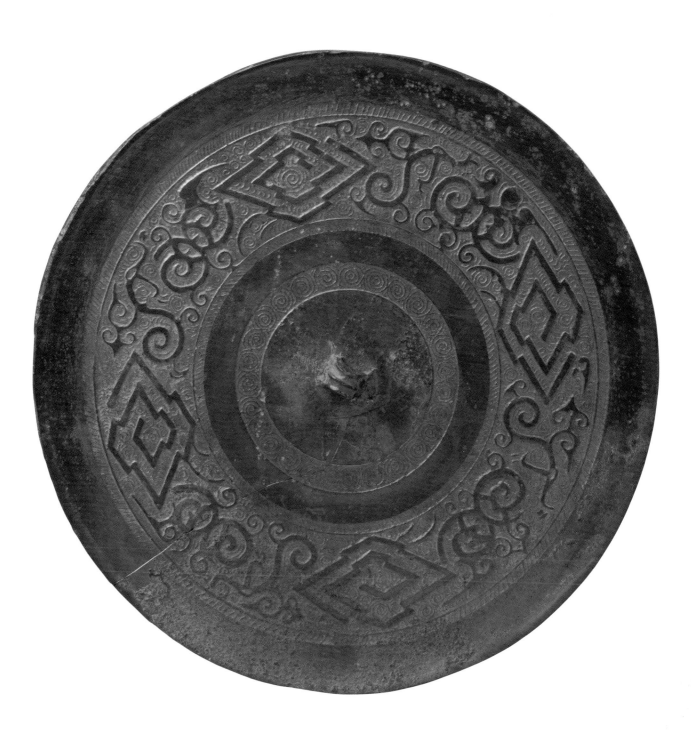

14

Tile End with Toad and Hare Design
Earthenware
QIN DYNASTY (221-206 B.C.)
Diam.: 6⅞ in. (17.5 cm)
Unearthed from the former site of the Ganquan Palace,
 Tiewangxiang, Chunhua county
Chunhua Cultural Museum

The eave tile, a round or semicircular roof component unique to ancient Chinese architectural design, served both a functional and a decorative purpose. Tile ends first appeared on buildings in the Western Zhou dynasty (1027-770 B.C.) and they were in common use by the Qin and Han dynasties. Their placement along the visually prominent edges of roofs and their flat ends made them appropriate for ornamentation with designs of animals, auspicious emblems, and scenes from ancient Chinese myths and legends.

The toad and the hare that decorate this tile allude to the story of Chang E, who stole the elixir of immortality given to her husband, Hou Yi, by the Queen Mother of the West and fled with it to the moon. There she became the Lady in the Moon, accompanied by the three-legged toad and the hare, who pounded the elixir with mortar and pestle. Tile ends decorated with the toad and hare design were auspicious symbols of good fortune and financial success, no doubt because of their connection with the elixir of immortality. On this tile, the hare is silhouetted from the side and the toad from above. The background is filled with a dynamic, organic pattern, framing the two figures tightly within the composition.

15

Tile End with Deer Design

Earthenware

QIN DYNASTY (221-206 B.C.)

Diam.: 5½ in. (14 cm)

Unearthed from the ruins of Yongcheng, Fengxiang county, 1982

Shaanxi Institute of Archaeology

The deer, another auspicious animal in Chinese cosmology, symbolizes longevity, because it is the only animal capable of finding the sacred fungus that ensured immortality. Deer, in a variety of poses, began to be represented on tile ends in the Warring States period (476-221 B.C.). Although depicted as a streamlined silhouette, the deer on this tile is still animated.

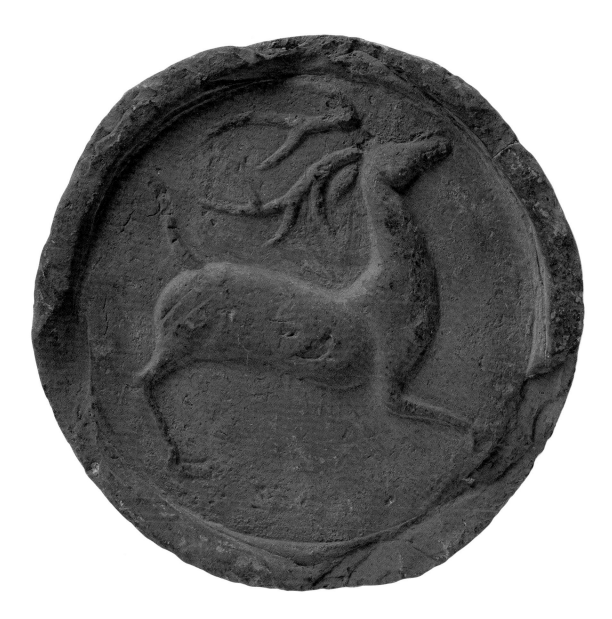

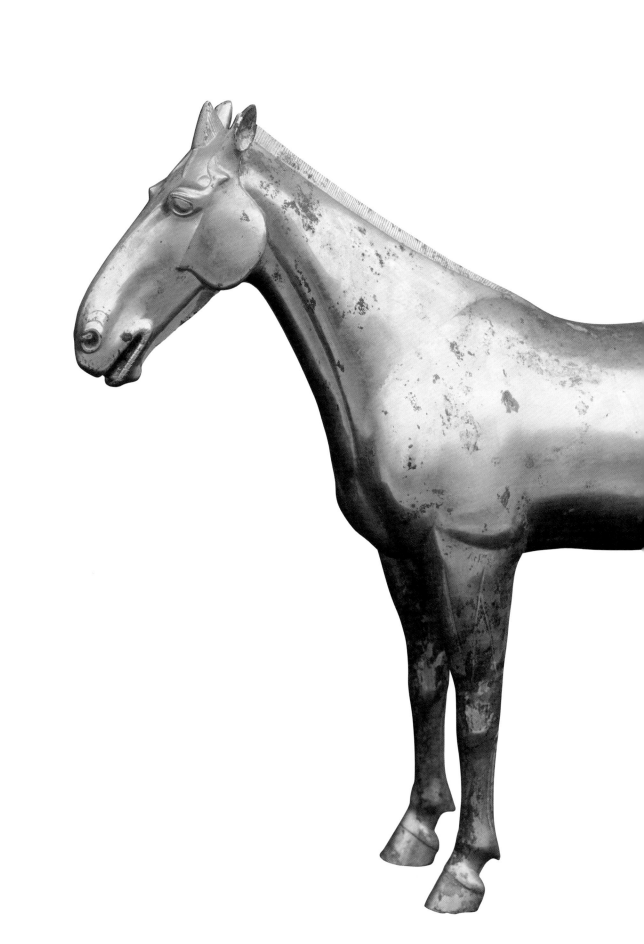

16

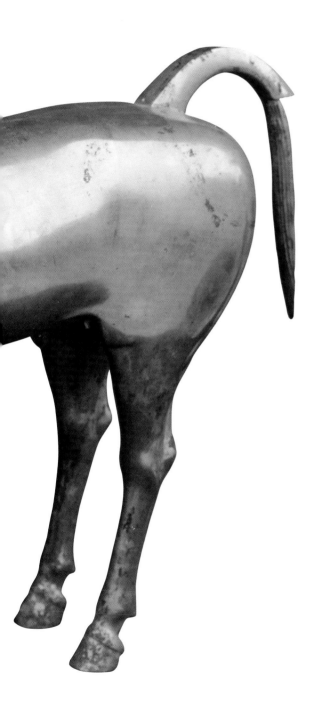

Horse
Gilt bronze
WESTERN HAN DYNASTY (206 B.C.-A.D. 9)
H: 24⁷⁄₁₆ in. (62 cm) L: 29¹⁵⁄₁₆ in. (76 cm) Weight: 25.5 kg
Unearthed from tomb no. 1, pit no. 5, east of Maoling,
 Xianyang, Xingping county, Shaanxi province, 1981
Maoling Museum

•

A row of five grand anonymous tombs lie east of Han Wudi's tumulus, Maoling, in Xingping county. In May 1981, villagers working in the area discovered a burial pit south of the westernmost tomb, identified as tomb no. 1. More than 230 relics were excavated, including bronze, iron, lead, and lacquer vessels, some functional, others funerary. Most of the vessels bear inscriptions that record the name of the vessel, its height, weight, capacity, place of production, and date of production or purchase. All were inscribed as belonging to the Yangxin family (*Yangxin jia*), a reference to the emperor's older sister, Princess Yangxinchang, the only person addressed as Yangxin during the period of Wudi (r. 141-87 B.C.).

Among the important cultural relics unearthed from the tomb was the largest gilt bronze animal figure discovered in China to date—this magnificent horse. Nearly one-third life-size, it is a splendid testament to the outstanding workmanship of Han dynasty artisans. Standing tall and erect on sturdy legs, with eyes open and looking forward, ears raised, and the mouth slightly open to reveal six teeth, the horse appears both alert and strong. The triangular shape of the head imitates the characteristics of the famous horses of the Western Region (*Xiyu*), known in Wudi's time as *tianma*, heavenly horses. According to historical records, Wudi wanted to import the finest horses from the city of Dayuan (present-day Ferghana) in the western region to use in his battles against the Xiongnu. He ordered his metalsmiths to produce a gilt bronze horse as a gift to the Western Region's ruler in the hope that he would receive some heavenly horses in return. His gift, however, was rejected. This so infuriated Wudi that he sent his general, Li Guangli, to wage war against the city of Dayuan. Two horse specialists who accompanied Li seized more than 10 heavenly horses from Dayuan. Wudi's admiration for his sister must have been great, given the scale of her burial, its proximity to his own, and the brilliant, heavenly gilt horse that accompanied her to the next world.

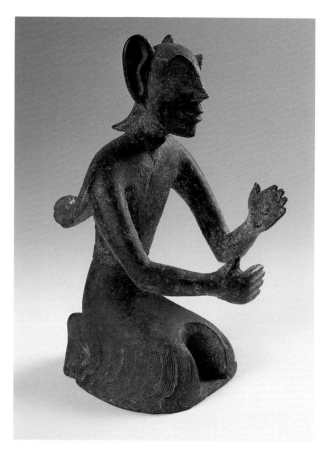

18

Lantern in the Shape of a Goose
Bronze with painted polychrome decoration
WESTERN HAN DYNASTY (206 B.C.-A.D. 9)
H: 21¼ in. (54 cm) L: 13 in. (33 cm)
Unearthed in Shenmu county, Shaanxi province, 1985
Shaanxi Historical Museum

•

The inventive nature of Han dynasty tomb artifacts is cleverly realized in this lantern in the shape of a goose with its head turned to face its back. Emerging from the goose's mouth is the simplified form of a fish, which is, in fact, the container for the lamp oil. Constructed from bronze, the entire surface is enhanced with delicately applied polychrome pigments, imparting an even greater sense of realism to the object. The beak, legs, and webbed feet are painted in vermilion while the eyes and feathers on the head are painted white. The neck, stomach, and back are given an undercoat of white and then decorated with a feather pattern using vermilion, so that in certain places the white pigment is revealed underneath. To give the appearance of being ruffled, the wings have been outlined in vermilion with details done in strokes of white and black.

The mechanics of this lantern are ingenious. Smoke from the lamp passes through the fish, up through the long neck of the goose, and down into the vessel's water-filled body, where it is dissolved, thus keeping the room free of smoke. Two pieces of bronze near the opening can be moved to control the height of the flame and the amount of air entering the lantern.

17

Winged Figure
Bronze
HAN DYNASTY (206 B.C.-A.D. 220)
H: 5⁵⁄₁₆ in. (13.5 cm)
Unearthed from Hanchengxiang, Xi'an, 1964
Cultural Relics Bureau, Xi'an

•

This broad-shouldered, narrow-waisted winged figure kneels as he stretches his arms in front of his chest as if he were holding something. He wears a long garment with a rounded collar, tight-fitting sleeves, and overlapping front, embellished at the hem with a pattern of nine pleated feathers. A pair of wings with a spiral cloud design projects from his shoulders. He has a long, narrow face with high cheekbones, protruding eyebrows, and enormous ears that stick out from the side of his head. Despite his ferocious countenance and unearthly appearance, he betrays a slight smile and is curiously appealing.

Feathered men (*yuren*) often appear in texts and pictorial art of the Han, especially the Eastern Han. The Han Chinese believed that immortals—those who had won freedom from death—dwelled in cloudy realms, where they flew weightlessly on feathered wings.

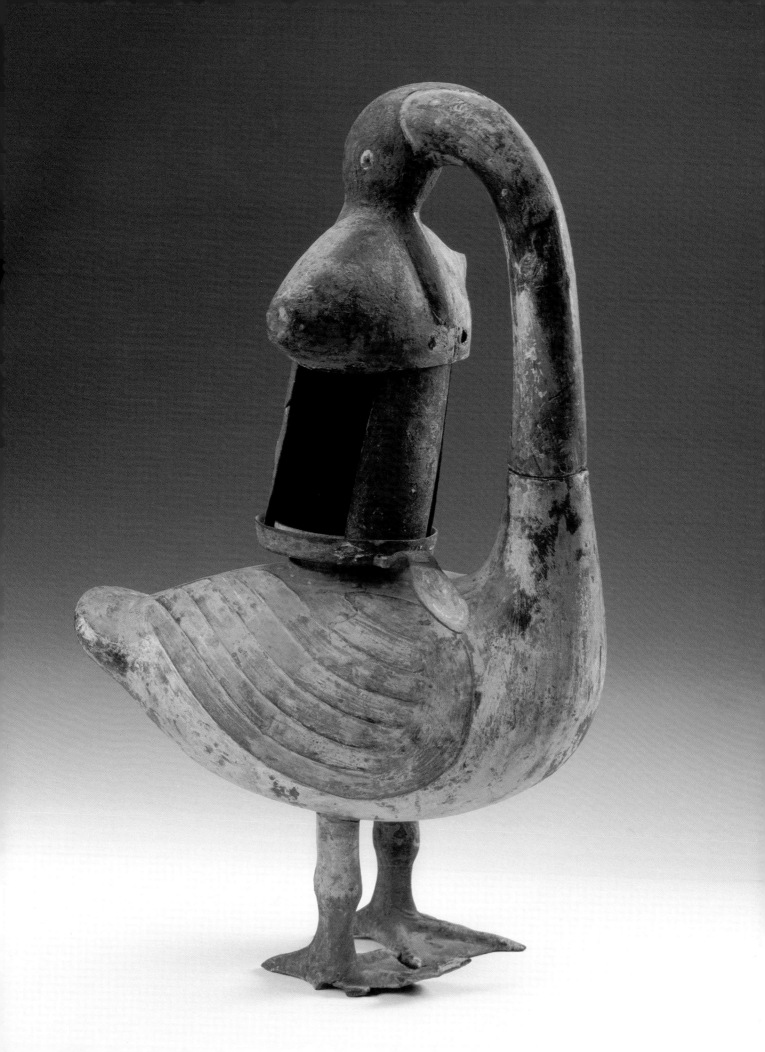

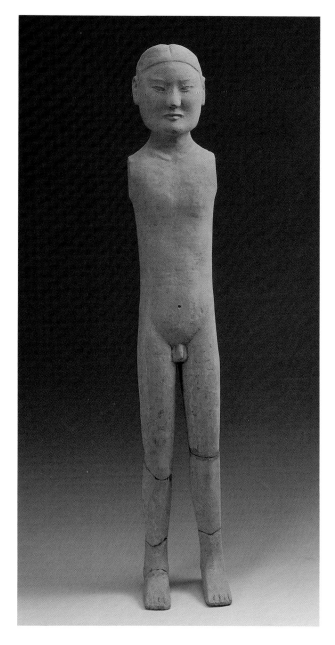 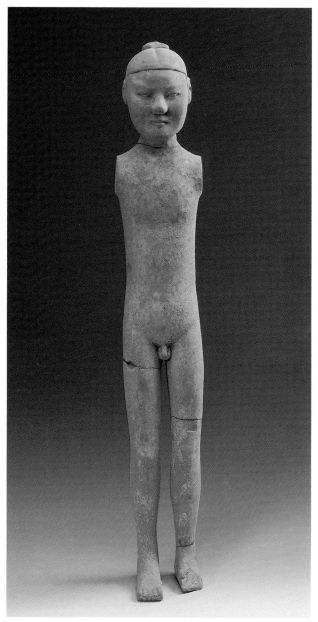

19

Pair of Standing Nude Males
Earthenware with painted polychrome decoration
WESTERN HAN DYNASTY (206 B.C.-A.D. 9)
H: 22¹³⁄₁₆ in. (58 cm)
Unearthed from Sanyi village, Xianyang, 1991
Xianyang Cultural Relics Protection Agency

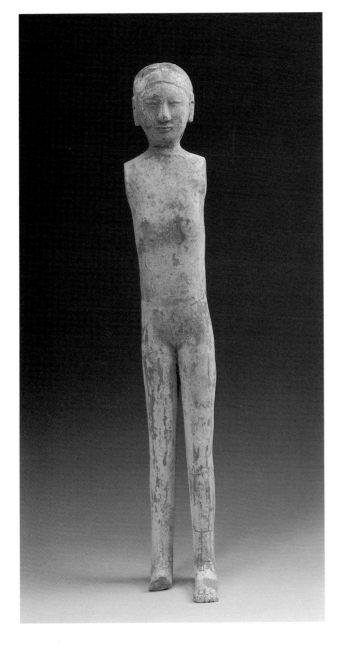
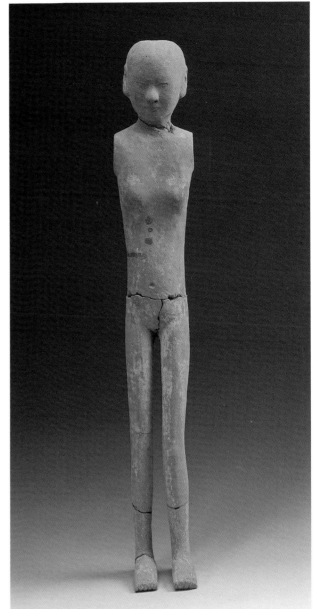

20

Pair of Standing Nude Females
Earthenware with painted polychrome decoration
WESTERN HAN DYNASTY (206 B.C.-A.D. 9)
H: 21¼ in. (54 cm)
Unearthed from Sanyi village, Xianyang, 1991
Xianyang Cultural Relics Protection Agency

These two pairs of standing nude figures were among the earthenware figures excavated from the attendant burial pits of the first Han emperor Gaozu's tomb, Changling. Originally fitted with moveable wooden arms, which are now destroyed, the figures were also adorned with fine silk garments which have since disintegrated, leaving the figures exposed. The figures have been modeled with great liveliness, realism, and anatomical precision, clearly delineating specific gender characteristics. Their faces express a wide range of emotions, personalities, and facial structures. The percentage of nude earthenware figurines excavated from Han tombs is small. Their recent discovery near the imperial tombs Yangling, Maoling, and Changling indicates they were popular in the capital and possibly were made especially for the Han emperors.

21

Horse
Earthenware with painted polychrome decoration
WESTERN HAN DYNASTY (206 B.C.-A.D. 9)
H: 22¹³⁄₁₆ in. (58 cm) L: 25¹⁄₁₆ in. (64 cm)
Unearthed from Zhuangtou village, Xingping county, 1984
Maoling Museum

•

The pervasive presence of horse figurines in Han tombs indicates a society with advanced agricultural and herding activities, one in which horses were integral to daily life. They not only provided an important means of transportation, as along the Silk Road, but were essential to success in warfare. The development of horse breeding in the Han made possible a strong national defense, particularly against invasions of nomadic tribes such as the proto-Mongol Xiongnu.

Han tomb art illustrates well the different breeds of horses they imported. In addition to the heavenly horses of Ferghana (cat. 16), the Samanthian (Wusun) breed from Xinjiang province was prized for its special qualities. The distinctive physical features of the Samanthian breed are given form in this regal sculpture, as well as in the horses of the mounted cavalrymen from Yangjiawan (cat. 25). These horses have small heads with large eyes and nostrils and tiny ears, moderately long arched necks, short but wide bodies, very strong limbs, and sturdy hooves. The massive volume and linear silhouette of the ceramic figures are analogous to the imposing quality exhibited in the monumental stone sculpture of the period. The example here, a conventionalized pottery model, is composed of detachable parts. The head, tail, and legs were all produced separately from the body, with the head and neck sometimes conceived in one piece. This specimen's entire body is intact, a rare find, as often only parts of a figure survive.

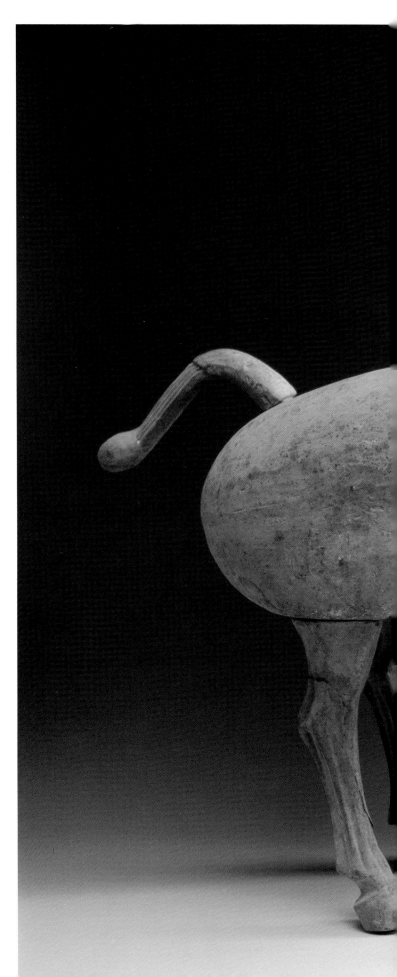

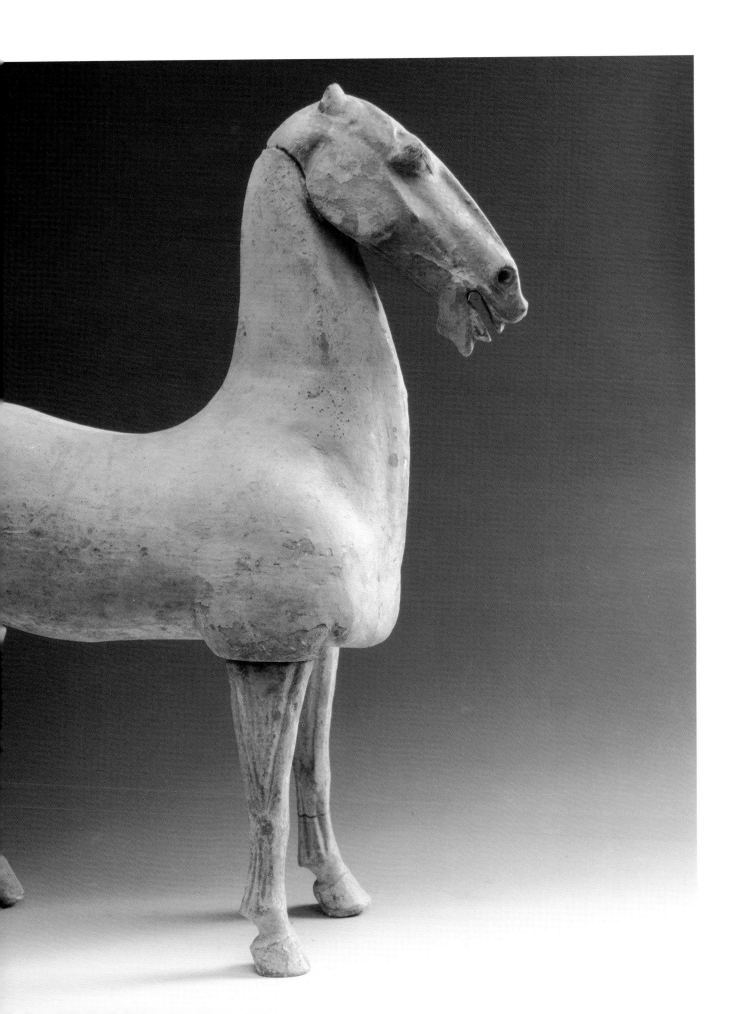

22

Camel

Earthenware with painted polychrome decoration
WESTERN HAN DYNASTY (206 B.C.-A.D. 9)
H: 29^{15}⁄₁₆ in. (76 cm) L: 38^{3}⁄₁₆ in. (97 cm)
Unearthed from Shapo in the eastern suburb of Xi'an, 1984
Cultural Relics Bureau, Xi'an

•

Zhang Qian, a native of Chenggu, Shaanxi province, made two journeys to the West, in 139 B.C. and 115 B.C., on orders from the Han Emperor Wudi. Zhang's travels covered Dayuan (Ferghana), Kangju (Samarkand), Scythia (north of the Amu-Darya river), and Bactria (south of the Amu-Darya river) and inaugurated a long period of profitable exchanges between China and the West. The impact of these cross-cultural dialogues is well recorded in the tomb figures of the Tang period.

For merchants and travelers navigating the arduous journey along the Silk Road, the camel became the most important mode of transportation. This adaptable creature, which can cover 30 miles a day with a cargo of 500 pounds, also can tolerate thirst and has an uncanny ability to locate local water supplies and avoid shifting sands. This tomb figure depicts a majestic Bactrian camel, the two-humped species found in Central Asia and regions of China along the Great Wall. The body is tall and slender, standing on legs that are long and strong, with the head held high. Traces of the original polychrome pigments are still evident.

23

Pair of Soldiers Holding Shields

Earthenware with painted polychrome decoration
WESTERN HAN DYNASTY (206 B.C.-A.D. 9)
H: 19^{5}⁄₁₆ in. (49 cm)
Unearthed from a Han tomb in Yangjiawan, Xianyang, 1965
Xianyang Museum

•

In August 1965 villagers leveling an area south of two Han dynasty tombs in Yangjiawan village, Xianyang, discovered a large number of painted polychrome earthenware figurines. Excavation established that the objects were the contents of the tombs' 11 satellite pits. Six pits contained cavalry riders and horses, four had foot soldiers, and one contained chariots. Altogether 583 mounted cavalrymen and horses, 1,965 infantrymen, and more than 100 dancers, musicians, and various attendants were unearthed. To date, this mausoleum is believed to contain the largest number of Han tomb figures excavated in Shaanxi province. These realistic figurines, arranged as a military funeral procession, were created with painstakingly detailed costumes, armor, hair-styles, and weapons. All of the excavated figurines are vividly painted with polychrome pigments which, for the most part, have remained remarkably preserved.

The carefully arranged pits may also re-create the battle formation of the early Han period, and the distribution of military units (cavalry, soldiers, chariots) within a square formation reveals

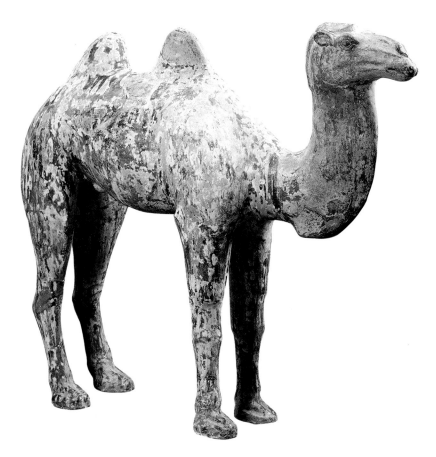

much about Han military strategy. The tombs at Yangjiawan date to the reigns of emperors Wendi (r. 180-157 B.C.) and Jingdi (r. 157-141 B.C.) of the Western Han dynasty. Scholars believe the tombs belong to Zhou Bo (d. 169 B.C.) and his adopted son Zhou Yafu (d. 143 B.C.). Both men served as prime ministers in the Western Han after earlier service as commanders-in-chief of the Han armies, which may account for the military flavor of their burials.

 The various military ranks of these Han tomb figures are distinguished by their official attire, armor, and weapons, as were the figures found near Qin Shihuang's tomb. But unlike the occasionally static bodies of Qin figures, Han tomb figures render the human form with a naturalistic sense of monumentality.

 These charming soldiers holding shields are indistinguishable in construction but are differentiated from one another by the painted details on their uniforms, which are similar to those on Qin archers (cat. 5, 6), right down to the armored vests. The soldier on the left wears an unadorned, collared, and belted robe in shades of red, with short pants and boots. His hair is parted in the middle and wrapped at the hairline with a red scarf. The figure on the right is dressed identically, with the exception of a vest and armored shoulder guards worn over his red robe. Both figures hold shields by their left sides and extend their right hands as if grasping weapons.

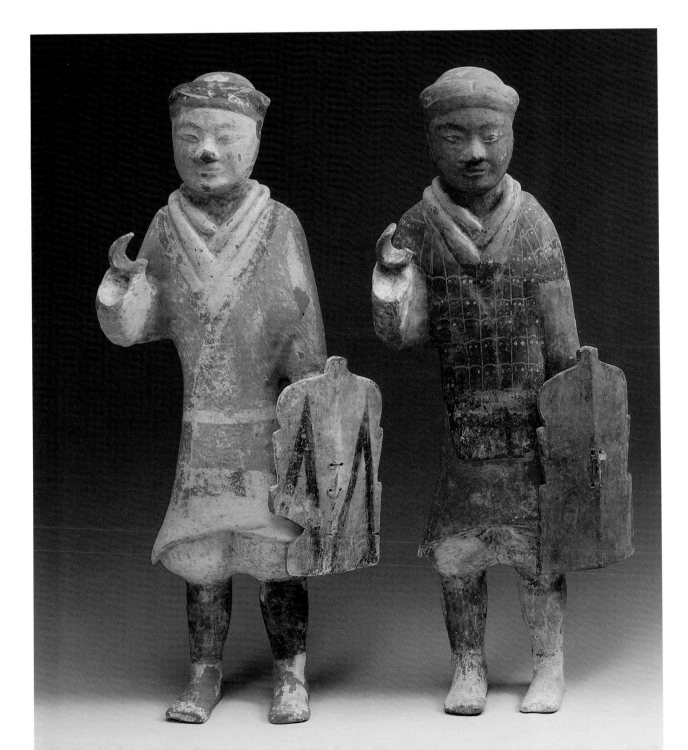

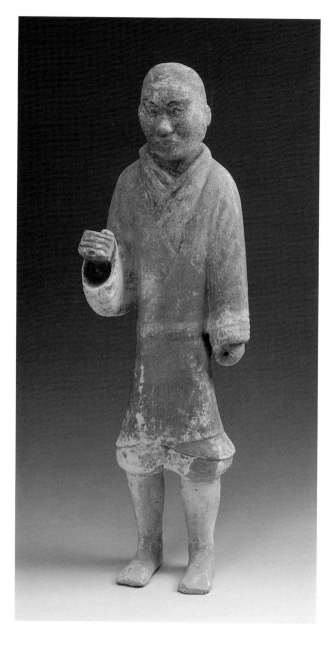
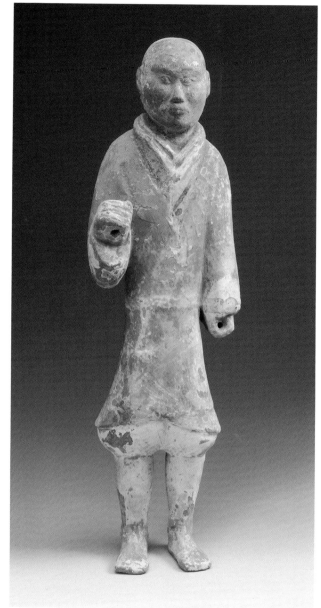

24

Pair of Standing Soldiers
Earthenware with painted polychrome decoration
WESTERN HAN DYNASTY (206 B.C.-A.D. 9)
H: 19⅛ in. (48.5 cm)
Unearthed from Weichengqu, Yangjiawan, Xianyang, 1965
Xianyang Museum

These two standing soldiers wear outfits similar to those worn by the soldiers with shields (cat. 23), but their heads are a little larger and rounder, their noses more slender, and their close-set eyes stare at the viewer with a fierce and determined gaze. Identically painted in polychrome pigments, both figures sport long, cinched red tunics with white collars and cuffs, tight pants, and white socks. Red turbans wrapped around their heads hold their hair in place. They hold their arms as if grasping shields in their right hands and weapons in their left.

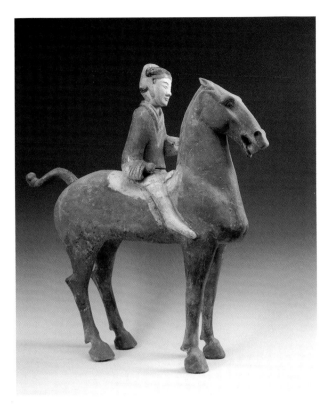

25

Pair of Mounted Cavalrymen
Earthenware with painted polychrome decoration
WESTERN HAN DYNASTY (206 B.C.-A.D. 9)
H: 25⅝ in. (65 cm)
Unearthed from a Han tomb in Yangjiawan, Xianyang, 1965
Xianyang Museum

In this spirited pair of mounted cavalrymen both figures and horses are colorfully painted. The horse on the right, with his red coat, broad chest, and short tail that curls high in the air, throws back his majestic head, with nostrils flared, mouth open, and teeth bared, as if neighing loudly. The black horse on the left holds a more static pose but exhibits the same regal physical traits. Wearing uniforms similar to those of the other Yangjiawan figures (cat. 23, 24), the cavalrymen straddle their mounts, poised to fight and ready to charge, holding the reins in their left hands and weapons in their right.

The placement of the pits containing the cavalry in a square battle formation demonstrates that by the Han dynasty the mounted cavalry had become an independent military unit with adequate fighting power necessary to defend the rear guard. The type of horse recovered in the Yangjiawan cache depicts the Samanthian breed, native to Ili in present-day Xinjiang province. It differs physically from the Ferghana breed represented by the Han dynasty gilt bronze horse excavated east of Wudi's tomb, Maoling (cat. 16). Both the Ferghana and Samanthian breeds were introduced to Han China after the opening of the Silk Road, and they were presented to the Chinese as diplomatic gifts. Rulers during both the Han and Tang empires put great emphasis on horse breeding. Representations of horses in various media are ubiquitous in Han, Northern Dynasties, and Tang tombs and are well illustrated here (cat. 4, 16, 21, 25, 33, 34, 42, 46, 52, 53).

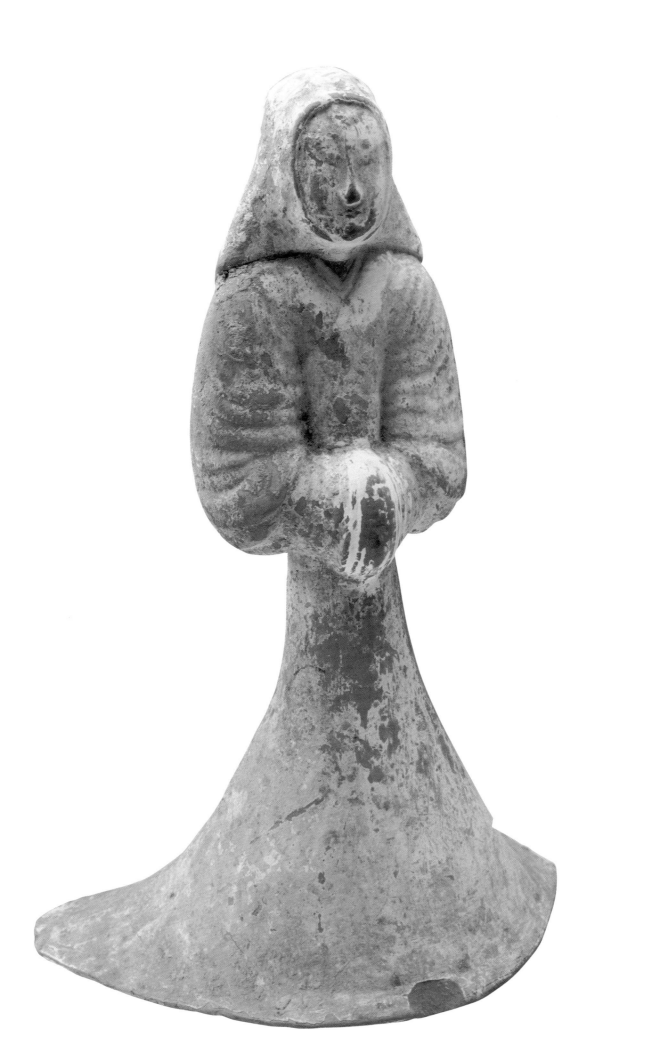

26

Female Figure with Hood and Flaring Skirt
Earthenware
WESTERN HAN DYNASTY (206 B.C.-A.D. 9)
H: 12³⁄₁₆ in. (31 cm)
Unearthed from the site of Han dynasty Chang'an,
　　Shaanxi province
Shaanxi Historical Museum

•

　　Among the many burial objects included in Han tombs, those depicting human beings were the most abundant. A wide range of personnel was represented, including military and official figures, guardians, entertainers, and, most commonly, domestic servants. The careful attention given to details of dress through modeling and painting furnishes important evidence about period clothing. Male and female attendants dressed alike, differentiated by their hairstyles.

　　This lovely figurine, dressed in simple, multilayered robes, the fashion of the time, also wears a protective hood that denotes her gender. Long inner sleeves conceal the arms and completely cover her hands, clasped in front of her body. The long skirt flares into a trumpet shape, accentuating her extremely narrow waist. The serene expression on her face has been modeled with great delicacy.

　　The carefully balanced proportions and graceful contour lines of this exquisite female figure epitomize the distinctive features of the Han sculptural tradition. A lack of muscular articulation and reduction of the natural form to bold contour lines give Han human figures a flat and inflexible appearance. Despite this formalized abstraction, artists achieved a lively and individualistic quality in these figures through the variation of facial features and expressions.

27

Pig
Earthenware
WESTERN HAN DYNASTY (206 B.C.-A.D. 9)
H: 4⁵⁄₁₆ in. (11 cm) L: 7½ in. (19 cm)
Unearthed in Xingping county
Xianyang Museum

•

　　In their desire to translate their worldly existence into the afterlife, the Han included a great variety of architectural and figural models in their tombs. Entire estates were imitated in pottery—courtyards, pavilions, towers (cat. 29), and barnyards. All types of domestic animals and fowl, such as pigs, oxen, horses, dogs, goats, chickens, and ducks, were rendered in three dimensions and placed in the tomb. These animal representations convincingly embody the spirits of the beasts they portray and are among the liveliest and most engaging of all the Han burial objects.

　　This ponderous figure of a pig looks as if he has just finished eating and is ready for a nap. He has a wide mouth that curls slightly upward, heavy eyes that look straight ahead, large ears flattened against the side of his head, and a short, curly tail. The thick bristles on the back of his neck stand straight up. Four thick, strong limbs support his sagging belly. The angularity of form and geometric conception of the body help create a sense of volume and mass.

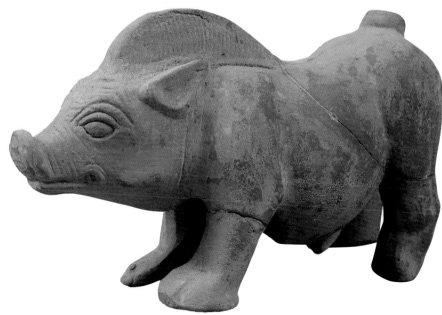

28

Ox

Earthenware with green lead-fluxed glaze
HAN DYNASTY (206 B.C.-A.D. 220)
H: 12⁹⁄₁₆ in. (32 cm) L: 21¼ in. (54 cm)
Unearthed from the suburbs of Xi'an
Shaanxi Historical Museum

•

 Figurines of hard-laboring oxen are commonly included in Han tombs. This strong, healthy ox, with his head slightly raised, has been covered in green lead-fluxed glaze like that on the pottery watchtower (cat. 29). Its bulging eyes are shaped like crescent moons, and its ears and horns point straight up. The front legs are planted firmly, but the two back legs are bent with the tail between the thighs.

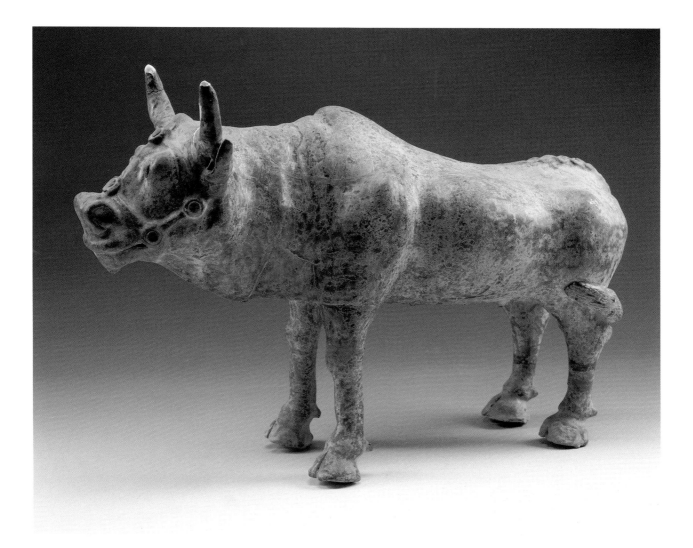

29

Watchtower
Earthenware with green lead-fluxed glaze
EASTERN HAN DYNASTY (A.D. 23-220)
H: 55⅛ in. (140 cm)
Unearthed from Beiyao village, Xinzhuxiang, Baqiaoqu, Xi'an
Cultural Relics Bureau, Xi'an

•

This green-glazed earthenware representation of a
five-story watchtower features seven figures looking out from the
balconies and the windows from the third, fourth, and fifth stories.
The complex bracketing system imitates that used in wooden
structures.

The technique of glazing pottery was developed in the
middle of the Western Han period. The earthenware surface was
covered with a low-fired, lead-fluxed glaze, with copper added as a
colorant, and fired to earthenware temperatures (600-800° C)
in an oxidizing kiln. Copper green and iron-derived yellow and
brown make up the normal palette of Han glazed pottery and
provide the foundation for the development of the three-color
(*sancai*) glazes of the Tang dynasty. Objects decorated with yellow,
brown, and green glazes have also been discovered around Baoji
county in Shaanxi province.

Architecture was one of the most innovative arts of
Han China. The original wooden structures have long since
disappeared, but tomb models such as this record the engineering
skills of the period. The construction of pottery towers suggests
that craftsmen utilized a combination of molding and hand-
crafting techniques, probably in a mass-production environment.
A wide variety of architectural models—including residential
compounds and towers, theaters, granaries, and barnyard struc-
tures—have been discovered at sites that primarily date to the
Han dynasty, though a few appear in excavations of earlier sites.

Freestanding towers were introduced into the repertoire
of architectural tomb models during the middle of the Eastern Han
period. By the late Eastern Han they had become a common
feature of rich tombs, and by the end of the Han the use of pottery
burial objects had expanded to include a wide variety of figures and
types of structures. The reason for their popularity is uncertain, but
it is known that during the Eastern Han elaborate funerals became
more and more common, perhaps as the result of an increased
desire to project a socially acceptable image of filial piety. The
inclusion of many and varied grave goods in the tomb may also
reflect the general wealth and prosperity of the period, as mass
production made these objects relatively affordable and
readily available. The specific mortuary function of these
towers is still unclear. In some cases they would appear to serve
a military function, while in other cases they have the character
of pleasure pavilions.

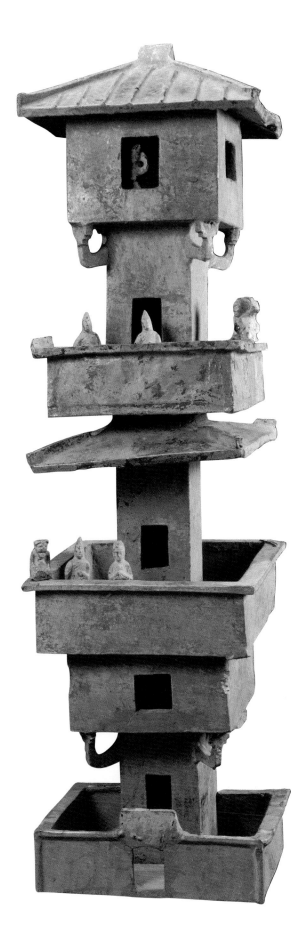

30

Hollow Brick Decorated with Red Bird Design
Earthenware
WESTERN HAN DYNASTY (206 B.C.-A.D. 9)
L: 45⅛ in. (114.5 cm) W: 14³⁄₁₆ in. (36 cm)
Unearthed from Guandao village, Xiwuxiang,
 Xingping county, 1983
Maoling Museum

•

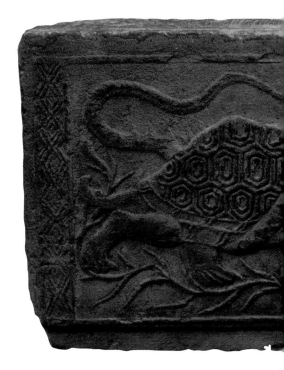

In the Han dynasty, mold-made, hollow-core, rectangular bricks used in tomb construction were often decorated with symbolic pictorial motifs. In Han cosmology, four fantastic animals symbolized the four cardinal directions: the green dragon of the east; the white tiger of the west; the red bird of the south; and the union of a snake and a tortoise (*xuanwu*), the Dark Warrior of the north. In burial structures, bricks depicting the four auspicious creatures were arranged to correspond with the four directions to orient the tomb and protect the soul of the deceased. This brick, painted with a pair of red birds flying in opposite directions, would have been positioned at the front of the tomb facing south. Each bird holds the pill of immortality in its mouth. Feathered crowns and two long plumes project from their heads. Their peacocklike tail feathers create a graceful and sinuous sense of movement. A flower bud hanging at the top center of the brick and the ball in relief at the bottom add visual interest.

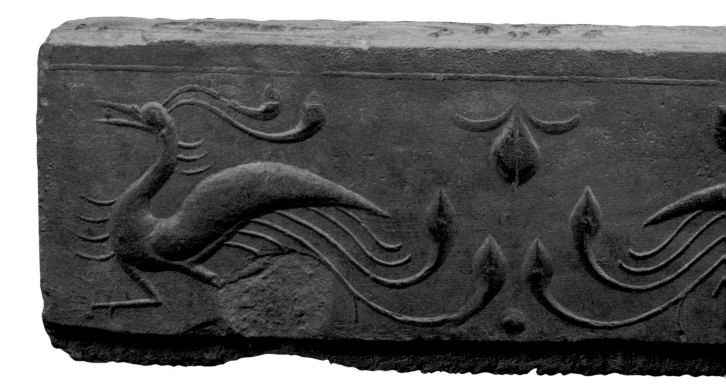

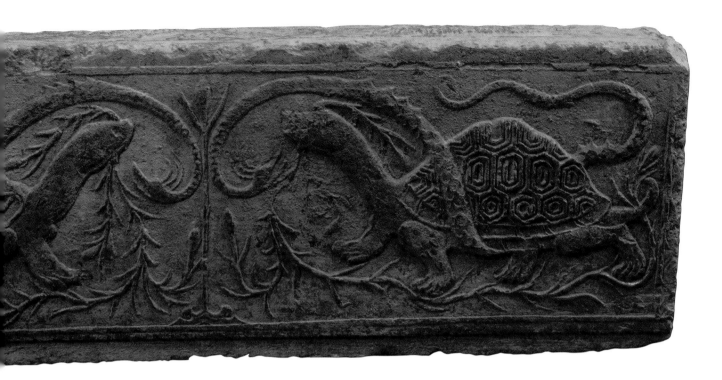

31

Hollow Brick with Dark Warrior Design
Earthenware
WESTERN HAN DYNASTY (206 B.C.-A.D. 9)
L: 46¼ in. (117.5 cm) W: 14¼ in. (37.5 cm)
Unearthed from Daochang village, Nanweixiang,
 Xingping county, 1974
Maoling Museum

•

This brick depicts the Dark Warrior of the north (*xuanwu*) and would have been placed at the back of the tomb opposite the red bird of the south. The two tortoises, each intertwined with a snake, face each other as in a mirror image. The snakes' mouths are open to receive the creeping tendril of vine from the tortoises, and the distinctive geometric pattern of the tortoises' shells is rendered with meticulous detail. In comparison to the light, graceful quality of the red birds, the *xuanwu* are substantial, solid, and menacing.

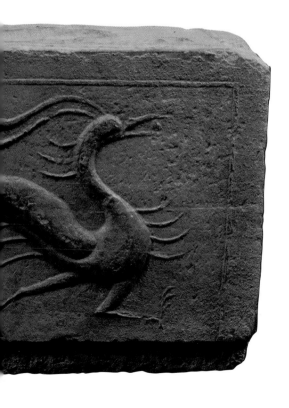

32

Bear
Jade
WESTERN HAN DYNASTY (206 B.C.-A.D. 9)
H: 1⅞ in. (4.8 cm) L: 3⅛ in. (8 cm)
Unearthed from Xinzhuang village, Zhoulingxiang,
 Xianyang, 1975
Xianyang Museum

•

From 1966 to 1976 a group of Western Han jades was excavated in the vicinity of the Han emperor Yuandi's (r. 49-33 B.C.) tumulus, Weiling, in Xianyang. The jade objects recovered included examples of three-dimensionally carved galloping horses, bears, lions, hawks, earth-spirit amulets, and figurine heads in white and green jade, ranging in size from 2.5 to 9 centimeters. Realistic and fantastic, delicate and charming, these objects attest to the Han artisan's technical skill in working jade, a hard, brittle material difficult to shape, and their artistic success in realizing volumetric forms.

This tiny jade bear was carved with a great degree of naturalism and sensitivity, exploiting the natural coloration on the jade pebble for full decorative effect. Very fine lines cut on the cheeks and legs to define the pelt signify that the entire body is covered in fur. The four legs positioned close together give the impression that the bear is walking, and his round eyes, open and alert, imbue the piece with a sense of animated spirit.

This small jade carving served as an amulet, to be kept in the pocket and continually caressed in the hand, to help endow the owner with strength and courage. The general popularity of bears during the Han is well documented. They were kept in imperial game parks, used in bearbaiting, and had an exorcistic role. The bearlike Chiyou, god of war, for example, exorcized drought and rain demons, and Han exorcists dressed in bearskins. The particular form chosen for this charm may be an illustration of an ancient rebus or visual pun based on the word *xiong*, which means "bear," but can also mean "brave."

33

Winged Figure on a Winged Horse
Jade
WESTERN HAN DYNASTY (206 B.C.-A.D. 9)
H: 2¾ in. (7 cm) L: 3½ in. (8.9 cm)
Unearthed from Xinzhuang village, Zhoulingxiang,
 Xianyang, 1966
Xianyang Museum

•

This carved amulet of a winged figure on a flying horse was found at the same site as the jade bear (cat. 32). The rider bears an uncanny resemblance to the bronze Han winged immortal (*yuren*) from Hanchengxiang (cat. 17). Both possess the same peculiar facial features, wings protruding from their shoulders, and garments hemmed in a feather pattern. The rider holds the reins in his left hand and a magic fungus, or *lingzhi*, in his right. The horse, wings carved across his torso, is in flight, with clouds forming the base of the sculpture. The physical attributes of this celestial horse recall the famous *tianma*, heavenly horses of Ferghana, ennobled in the gilt bronze example from Maoling (cat. 16), which the Chinese refered to as "blood-sweating" horses. Han Wudi (r. 141-87 B.C.), who dispatched Zhang Qian to the West to find the heavenly horses, hoped to ride one to the immortals' realms.

The jade used to carve these figures came from ancient Khotan in Central Asia (modern Xinjiang province) and was carried along the Silk Road to Chang'an. There the Han jade carver employed a range of techniques, combining relief carving, carving in the round, and drilling and hollowing out to achieve a sense of movement and volume.

34

Pair of Mounted Cavalrymen
Earthenware with painted polychrome decoration
NORTHERN WEI DYNASTY (386-535)
H: 14¾ in. (37.5 cm)
Unearthed from Caochangpo in the southern suburb of
 Xi'an, 1953
Shaanxi Historical Museum

•

Following the fall of the Han empire, China entered
into a period characterized by political instability, a stagnating
economy, and foreign invasion. It would be four centuries before
the country was reunified under the rulers of the Sui (581-618) and
Tang (618-906) dynasties. The tomb pottery produced during this
turbulent period can be divided into three broad chronological
phases. In the first phase, from the third and fourth century,
artisans were still working in earlier Han dynasty styles. In the
second phase, from the late fourth to early sixth century, new
stylistic innovations began to appear, due in part to the presence
of new ethnic groups in China. In the third phase, from the second
half of the sixth century, a more three-dimensional, naturalistic
idiom was expressed, which looked forward to the mature style
of the Tang dynasty.

The 158 tomb figures excavated from a tomb in
Caochangpo, a southern suburb of Xi'an, are representative of
the second phase of development. The Toba, a Turkic people,
established the Northern Wei dynasty in 386 and brought a new
cultural bias to China. Foreign influence is reflected in new types
of tomb figures, in the fresh approach to detail features, and in
stylistic conception. The earthenware objects present a wide
range of figure types, including armored warriors, cavalry, female
attendants, entertainers, and animals. The presence of many
military personnel in this tomb is a sign of the troubled times
and suggests that affluent citizens made efforts to maintain
personal armies.

This pair of mounted cavalrymen, wearing tall helmets
and suits of armor and sitting astride armored horses, exemplifies
one of the new tomb figure types to emerge during the Northern
Wei dynasty. The practice of fitting the horse with armor was
introduced to China in the Northern Wei dynasty from Persia
by way of Western Asia and Xinjiang. The straight ears of the
horses and their stocky bodies balanced on four short, sturdy legs
are characteristic of the Mongolian breed. The soldiers wear long
pants and tight-fitting robes with high collars. The entire ensemble
is mold-made, finished with incised and relief techniques, and
painted. These figures are the earliest examples of cavalrymen on
armored horses excavated in China, providing an illustration of the
military equipment of the period. Although the figure type and
rendering of stylistic details are innovative, the figures still possess a
naive quality in the general conception of form, reminiscent of the
earlier Han figures.

35

Dog
Earthenware
POST NORTHERN WEI (late sixth century)
L: 5⅞ in. (15 cm)
Unearthed from Hongguang village, Changlingxiang,
 Ankang county, 1982
Shaanxi Historical Museum

•

In 1982 a rectangular tomb chamber was discovered in Hongguang village in Ankang county. Though the tomb had collapsed, close to 100 funerary objects survived, over half of which were human figures—honor guards, warriors, attendants, servants, two non-Han "barbarians," and a civil official. Also found were six animals and one animal guardian. The remaining articles consisted of glazed and unglazed earthenware crockery. The precarious economy of the Northern Dynasties period (386-581) is reflected in the simpler tomb construction and relatively modest number of grave goods included in the burial. The structure of the tomb, the green-glazed stoneware found there, and the costumes of the figurines are all consistent with dated items from the late sixth century excavated from the same area.

This recumbent dog was one of the six animal figures in the tomb. His head rests on folded paws, his tail is curled beneath his hind legs, and his floppy ears hang down at the sides of his head. Dogs appear frequently in tomb art from this period. They are modeled much more realistically than their Han counterparts, foreshadowing the plasticity and naturalism that are the achievement of Tang burial art.

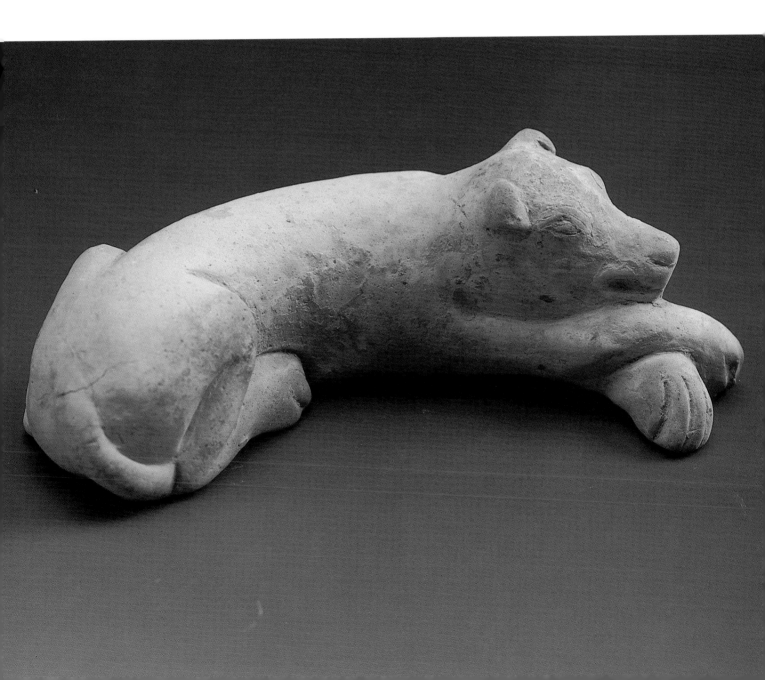

36

Honor Guard
Earthenware
POST NORTHERN WEI (late sixth century)
H: 12³⁄₁₆ in. (31 cm)
Unearthed from Hongguang village, Changlingxiang,
 Ankang county, 1982
Shaanxi Historical Museum

•

Although plagued by political factions and economic decline, the Northern Dynasties period saw much creative development in the arts. During this period Buddhism was introduced to China, through which the cultures of India and Central Asia were subsequently assimilated into the Chinese artistic lexicon. The presence of non-Chinese rulers in Northern China influenced the style and costuming of tomb figures.

This honor guard was one of 15 such figures included in a post Northern Wei, sixth-century tomb excavated in Hongguang village. His wide-sleeved, sashed tunic and loose, flared trousers tied at the knee resemble the attire of the Turkic Toba Northern Wei. He wears an unusually tall hat with a very wide brim. His hands, now missing, may have held an instrument or perhaps a banner of some kind. The attenuated form and elegant pose of the body are reminiscent of Northern Wei figures.

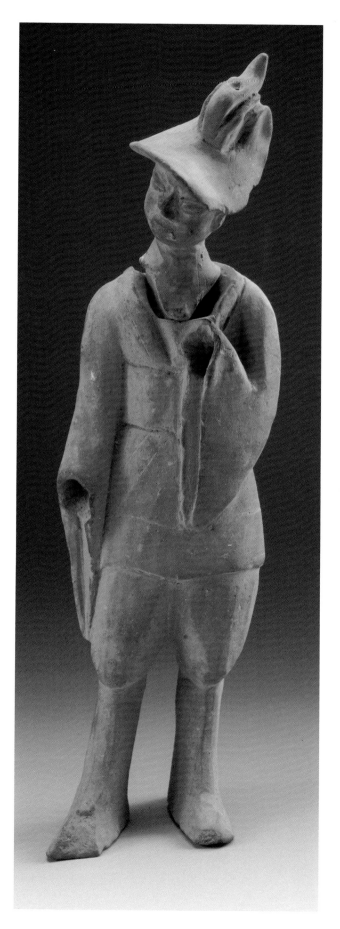

37

"Barbarian" Soldier
Earthenware
WESTERN WEI (535-557)
H: 5⅞ in. (14.9 cm)
Unearthed from the tomb of Hou Yi at Hujiagou, Yaodian,
 Weicheng district, Xianyang, 1984
Shaanxi Historical Museum

•

 The epitaph inscribed on a Western Wei tomb,
unearthed from beneath the Cangzhang brick factory in Hujiagou,
identifies its occupant as Hou Yi, son of the provincial governor
of Yanzhou, who was entombed in 544, the tenth year of Datong.
Excavated from December 1984 to January 1985, the tomb
contained a single chamber with an entrance passage, a corridor,
and a coffin. Although the tomb had been robbed, 160 artifacts
were recovered, most of them earthenware, but also a few objects
made of bronze, iron, and lacquer. The burial figures included
the standard retinue of military personnel and civil officials, male
and female attendants, animals, and guardians, as well as architec-
tural models and utilitarian vessels. Notable, however, was the
presence of 21 musicians on horseback and the figure of a non-Han
"barbarian."

 By the year 535 the Northern Wei Toba had split
into the short-lived Eastern Wei (534-550) and Western Wei
(535-557). During this time the attenuated style of the late
Northern Wei evolved toward greater solidity of columnar forms.
This figure of a non-Han "barbarian" soldier found in the tomb of
Hou Yi illustrates the increasing presence of foreign figures in the
tomb, which paralleled the continuing influx of alien cultures into
northern China. This rotund person bears no physical resemblance
to the gracefully elongated physiques of the Wei figures. He has
long, curly hair which covers his shoulders, deep-set eyes, and a
high nose. His long tunic has a round collar and narrow sleeves
with a belted waist. He wears a pair of heavy boots. His right
hand at his chest and his left hand to his side are each curled into a
fist. Holes in the cavities formed by his two fists indicate he was
originally holding something, probably a weapon. The placement
of the solitary figure between the Chinese soldiers and the musi-
cians in the central area of the tomb indicates its difference from
more traditional figures.

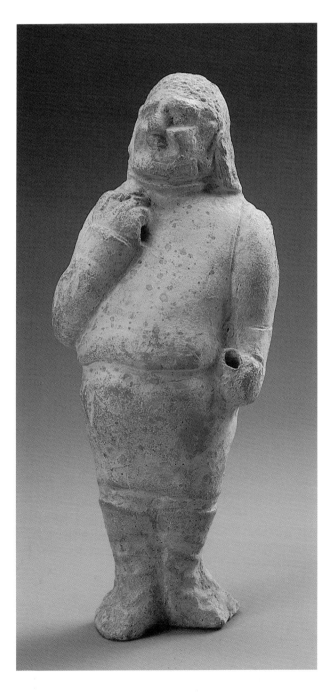

38

Tomb Guardian

Earthenware
WESTERN WEI DYNASTY (535-557)
H: 14⁹⁄₁₆ in. (37 cm) L: 12³⁄₁₆ in. (31 cm)
Unearthed from Cuijiaying village, Wuxiang county,
 Hanzhong, Shaanxi province, 1977
Shaanxi Historical Museum

•

A Western Wei tomb located in Cuijiaying village was discovered and excavated in 1977. Built of bricks with front and back chambers connected by a corridor, conforming to the shape of the Chinese character *tu*, 土 (earth), the tomb had been plundered, but the funerary objects were in their original positions in the front chamber. Of the 76 earthenware figurines recovered most were civil and military figures arranged in an honor-guard formation. The other figures included several human attendants holding objects, an ox and a horse, and an animal guardian. Although the objects in the tomb resemble the contents of Northern Wei tombs in central Shaanxi, the figures have distinguishing features—extremely baggy trousers, for example—that date this tomb to the Western Wei. Guardian beasts like this one are also typical in Western Wei tombs.

The tomb guardian found in the front chamber has the body of an animal and a human face. He sits on his haunches with his front legs extended and his tail curled up underneath him. He originally had a tattoo on his back. The head, tilted back, emphasizes the large, pointed nose, flaring nostrils, and wide, staring eyes. His mischievous grin adds to his wild, emphatic presence.

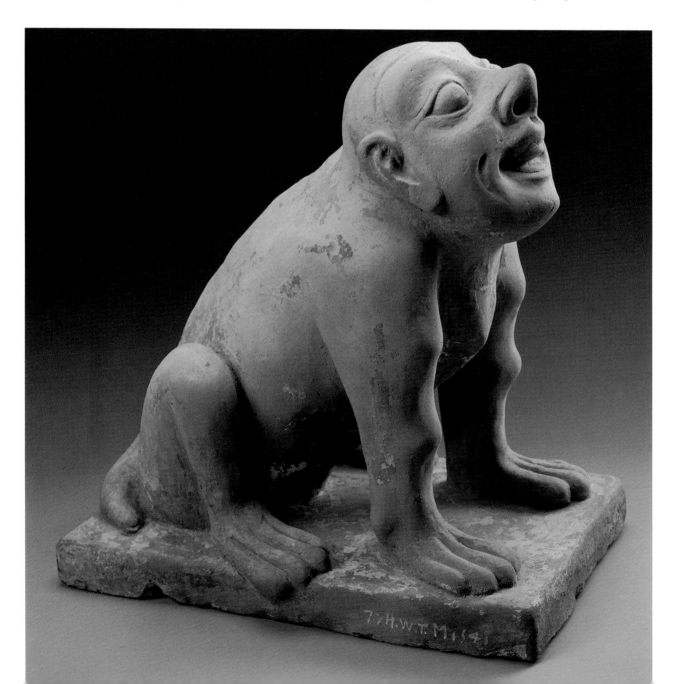

39

Camel
Earthenware
WESTERN WEI (535-557)
H: 7⅞ in. (20 cm) L: 8¼ in. (21 cm)
Unearthed from the tomb of Hou Yi at Hujiagou, Yaodian,
 Weicheng district, Xianyang, 1984
Shaanxi Historical Museum

Funerary sculptures of camels began to appear with regularity among grave goods during the period of the Northern Dynasties, although examples dated to the Han dynasty have also been unearthed (cat. 22). Like the human figures of the period, camels were depicted with heads relatively small in proportion to their bodies. This one stands firmly on sturdy legs and thickly padded feet, and the modeling gives him a real sense of solidity and weight, a quality the "barbarian" soldier from the same tomb shares (cat. 37). On top of the saddle and a blanket, the camel's cargo, rendered in accurate detail, consists of a large piece of twisted cloth, secured to two wooden boards that hang over the sides of his hump.

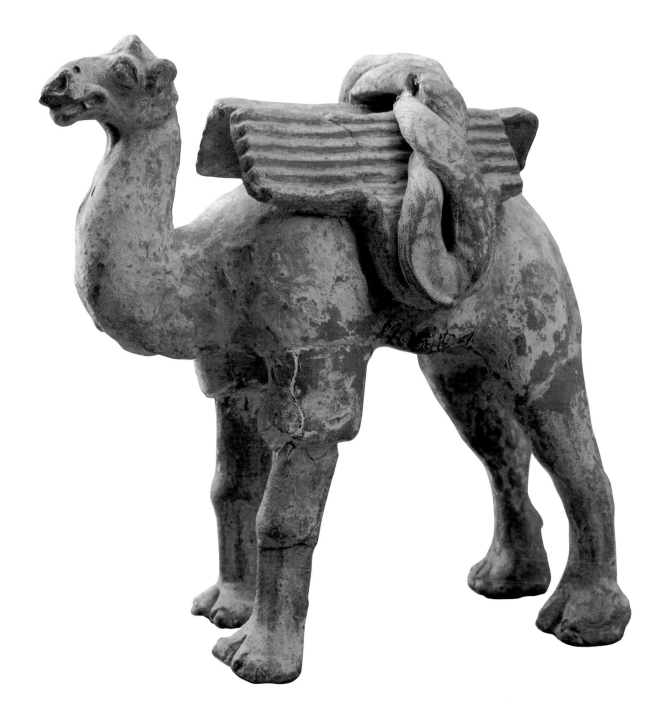

40

Mirror Decorated with the
Twelve Animals of the Chinese Zodiac
Bronze
SUI DYNASTY (581-618)
Diam.: 7¹³⁄₁₆ in. (19.8 cm)
Unearthed from Xingping county
Xingping Cultural Relics Bureau

•

The inner ring of this mirror contains four pairs of animals, each in a different pose; the outer ring depicts the 12 animals of the Chinese zodiac chasing each other. An overall grapevine design, symbolic of good fortune, fills the background, and the raised border is decorated with creeping vines.

Twelve celestial animals make up the Chinese zodiac: the rat, the ox, the tiger, the rabbit, the dragon, the snake, the horse, the goat, the monkey, the rooster, the dog, and the pig. The designation of the 12 creatures as a group, which originated in the Warring States period, was well established by the Eastern Han, when they were used in the Chinese calendar to record the month and the year. By the Northern Zhou dynasty (557-581) it was common to associate a person's birth year with the animal assigned to that cyclical year, and later, in the Sui and Tang dynasties, the Chinese prayed to the 12 animals for good luck. As auspicious emblems, their use in tomb interiors and as mirror designs was widespread. The zodiac mirror, in particular, which was placed in the tomb to deflect evil spirits, became extremely popular in the Sui and Tang dynasties.

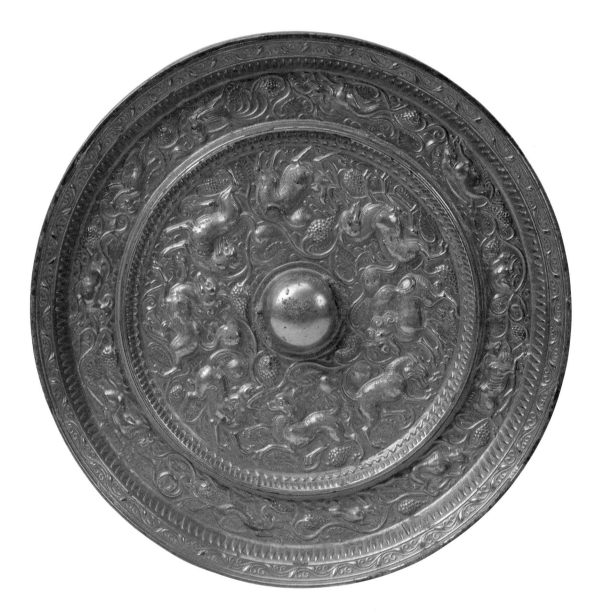

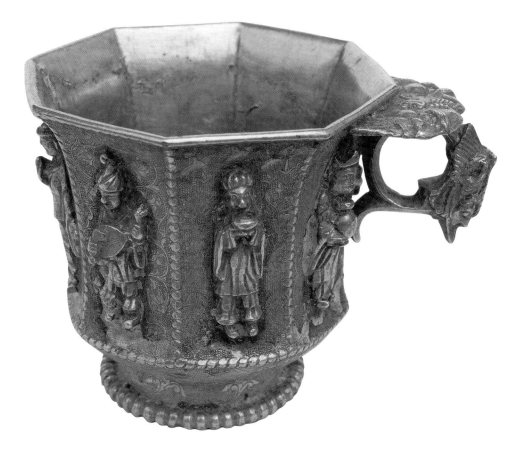

41

*Octagonal Cup Decorated with
Musicians and Dancers*
Gilt silver
TANG DYNASTY (618-906)
H: 2⅝ in. (6.6 cm) Diam. of mouth: 2¹³⁄₁₆ in. (7.2 cm)
Unearthed from Hejia village in the southern suburb of Xi'an, 1970
Xi'an Beilin (Forest of Stone Tablets) Museum

•

In October 1970 two urns were unearthed from a cellar in Hejia village on the southern edge of Xi'an. More than 1,000 relics were excavated, including gold and silver objects, ornaments inlaid with precious gems, expensive medicines, Chinese and foreign coins, and silver ingots. Among the artifacts recovered were five Japanese *wakokaichin* coins dated 708, issued in Nara during the reign of Empress Gemmei (707-715), a Byzantine gold coin of the Eastern Roman Empire bearing the profile of Heraclius (610-641), a Sassanian silver coin from the reign of Chosroes (Khosru) II of Persia (560-627), and many silver coins of the Tang Kaiyuan period (713-741). These artifacts help date the find and also provide evidence of the widespread cultural exchanges that took place between China and Japan, Persia, and other Western Asian countries during the Tang dynasty.

The most exquisite objects among the hoard are 270 gold and silver artifacts notable for the high quality of their execution and their technical mastery. Of the large variety of bowls, plates (including one large silver plate dated 731), cups, boxes, food vessels, instruments, and jewelry, five objects from the Hejia cache represented here (cat. 41-45) are exemplars of the wide range of form, sumptuous decoration, and superb craftmanship attained by Tang gold and silversmiths.

The shape of this octagonal cup, with a flaring mouth, a trumpet-shaped footring, and a ring handle, is Near Eastern in origin. The top of the handle is decorated with the heads of two men looking in opposite directions, while the side of the handle is decorated with an animal head. Each of the eight facets is adorned with a figure in high relief. Four are musicians: one holds a set of clappers, one a cymbal, one an oboe, and one a mandolin. The remaining four panels depict a man holding a bottle, another holding a cup, and two dancers. The figures are foreigners with deep-set eyes and large, pointed noses; they wear hats with upturned rims and float on a ground embellished with honeysuckle scrolls, rocks, birds, and butterflies and filled in with a stamped ring pattern. A string of beads in relief frames each facet and the bottom rim of the footring, which is decorated with interlocking honeysuckle scrolls.

The use of foreign entertainers as a decorative motif attests to their presence and popularity in the Tang capital.

42

*Flask with Design of Dancing Horse
Holding a Cup in Its Mouth*

Gilt silver
TANG DYNASTY (618-906)
H: 7 5/16 in. (18.5 cm) Diam. of mouth: 7/8 in. (2.2 cm)
Unearthed from Hejia village in the southern suburb of Xi'an, 1970
Xi'an Beilin (Forest of Stone Tablets) Museum

•

The shape of this wine flask is unique to the Chinese metalsmith's craft. Fashioned from silver and gold, the form imitates the leather bottles commonly used by nomadic tribes living in northern areas of China. Modern excavations have yielded examples of this type of container interpreted in the ceramic medium as well. The curved handle and the loose cover in the shape of a lotus blossom are gilt.

Identical images of a horse holding a cup in its mouth decorate either side of the flask. The horse sits on his hind legs, his front legs outstretched, his head held up slightly, and his large eyes open. A long scarf tied around the horse's neck trails behind his head. A luxuriant mane and long, bushy tail curling up in the air give the horse an elegant flourish. The technique of gold repoussé used to create the figure of the horse utilizes the contrasting colors of the two precious metals to give three-dimensional definition to the musculature of the horse and the thick mane. The oval-shaped bottom of the flask, which had been beaten and then soldered to the body, is delineated by a braided chain.

According to Tang records, the Emperor Xuanzong (r. 712-756) kept 400 horses trained to dance and respond to the tempo of musical arrangements. Certain horses danced to the accompaniment of an orchestra conducted by two singing females; one special group of horses performed at banquets celebrating the emperor's birthday on the fifth day of the eighth month of each year. The horses depicted on this flask illustrate a special dance in which, at each refrain of the music, the musicians would fill the horse's cup with wine, whereupon the horse would drink the beverage, delighting the emperor and his guests. Sadly, during the course of the An Lushan Rebellion in 756, the dancing horses were dispersed, many back to the frontier.

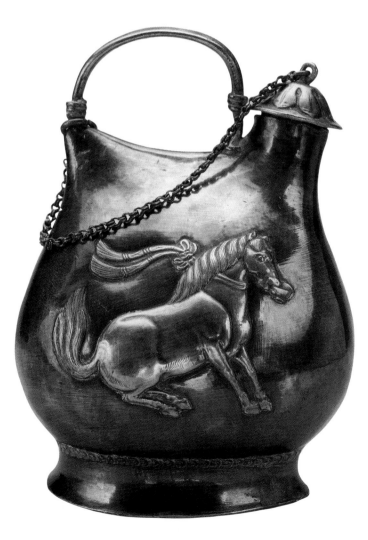

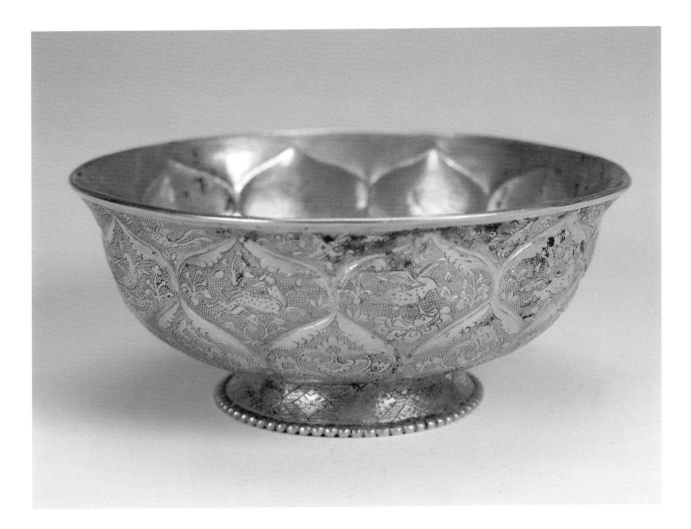

43

Bowl with Design of Mandarin Ducks and Lotus Petals
Gold
TANG DYNASTY (618-906)
H: 2³⁄₁₆ in. (5.5 cm) Diam. of mouth: 5³⁄₈ in. (13.7 cm)
Unearthed from Hejia village in the southern suburb
 of Xi'an, 1970
Shaanxi Historical Museum

•

Commerce and travel along the Silk Road brought an influx of both foreigners and goods into the Tang capital at Chang'an, which in turn had a profound effect on the artistic innovations of the period. The peace, prosperity, and political stability of the Tang dynasty are reflected in its artistic achievements, particularly in the field of gold and silver production. A strong economy and affluent middle class created an increased demand for luxury articles made from precious metals, stones, and gems. Although precious metal production had existed since the Shang dynasty (16th-11th century B.C.), it had been used primarily for inlay decoration on bronze vessels. During the Tang dynasty, the manufacture of objects brilliantly crafted solely in the medium of gold and/or silver reached its height.

This bowl, a magnificent example of Tang gold ware, represents the pinnacle of achievement reached by goldsmiths of the period. This bowl, which flares at the lip and sits on a trumpet-shaped foot, was created by a combination of skillful techniques. Shaped by beating, the body is formed by repoussé work into two rows of lotus petals, each with 10 petals. The exterior of the bowl is decorated with chased designs on a ground pattern of stamped circles. The upper layer of petals is decorated with animal designs including a fox, a hare, a roebuck, a deer, a parrot, and a mandarin duck on a background filled with plants and lotus blossoms. The bottom layer of petals is engraved with honeysuckle scrolls, the surface of the footring is covered with lozenge patterns, and the foot is rimmed in a ring of beads in relief. The interior of the bowl is decorated with a rosette pattern. Three Chinese characters, inscribed in ink on the inside cavetto of the bowl, record the weight of the vessel as 9½ taels, indicating that the production of gold and silver wares in the Tang dynasty was closely supervised.

44

Square Box with Design of Peacocks and Phoenixes
Silver
TANG DYNASTY (618-906)
H: 3¹⁵⁄₁₆ in. (10 cm) L: 4¾ in. (12 cm) W: 4¾ in. (12 cm)
Unearthed from Hejia village in the southern suburb of Xi'an, 1970
Shaanxi Historical Museum

•

This lavish repoussé silver box, completely covered with chased designs in a dense decorative motif, probably served as a container for other precious objects. Standing on lotus pedestals, two peacocks spread their plumage on the front panel; they hold lotus pods in their mouths. The bottom corners are filled with wooded mountain peaks against a background of flowers, birds, and clouds. The right panel features two infants playing with a dog, while in the left panel phoenixes perch amidst honeysuckle scrolls. The rear panel depicts wild geese standing on symmetrically arranged lotus pods, again with a background of birds, plants, peaks, and clouds. The cover, attached with an elaborate hinge, is decorated on top with honeysuckle blossoms and on the sides with honeysuckle scrolls. The entire ground of the box is filled in with a stamped ring design.

45

Round Box with Mythical Beast Design
Gilt silver
TANG DYNASTY (618-906)
H: ⅞ in. (2.2 cm) Diam.: 2⅜ in. (6 cm)
Unearthed from Hejia village in the southern suburb of Xi'an, 1970
Shaanxi Historical Museum

•

Small gold or silver boxes were fashionable with wealthy ladies during the Tang dynasty for use as cosmetics or toiletry containers. Larger containers may have served as incense burners. The popularity of these small boxes during the Tang provided the metalsmith ample opportunity to experiment and to combine a wide variety of decorative motifs in imaginative ways.

A deer with wings and antlers and a long ribbon trailing from its mouth is engraved on the cover, surrounded by a scroll of eight interlocking lotus leaves. The base is decorated with a phoenix with a ribbon in its beak, encircled by an interlocking honeysuckle scroll. Both the cover and the base of this box are convex. The rims are decorated with floating clouds and birds in flight, and the entire ground is filled with a stamped ring pattern.

46

Dancing Horse
White earthenware
TANG DYNASTY (618-906)
H: 18½ in. (47 cm) L: 21¼ in. (54 cm)
Unearthed from the tomb of Zhang Shigui in Liquan
 county, 1972
Shaanxi Historical Museum

•

The tomb of Zhang Shigui (d. 657), located 300 meters south of Mazhai village in the town of Yanxia in Liquan county, was one of the attendant tombs that accompanied the Tang emperor Taizong's (r. 626-649) mausoleum, Zhaoling. The 57-meter-long tomb, excavated in 1972, was composed of a brick coffin chamber, a corridor, and a passage with four small niches in which most of the 409 burial objects were found, including male and female figurines, horsemen, horsewomen, musicians, and animals. An epitaph carved in seal script reads, "This is the epitaph of the Great Tang former Assistant State General, the military governor of Jingzhou, Duke of Guo, Mr. Zhang."

Some 307 polychromed and glazed ceramic sculptures of humans and animals provide important evidence about early Tang social relations, customs, and costumes. Significant among them is this white glazed earthenware horse with elegantly groomed, wavy mane and twisted tail. This muscular and fleshy horse stands with its head cocked to one side, its mouth open. His right front hoof is raised and his head and neck turned as if dancing to music, perhaps representing one of the trained dancing horses kept by Emperor Xuanzong (or Minghuang, r. 712-756) to entertain guests at his birthday celebrations. Another image of a dancing horse is depicted on the silver flask that was excavated from a Tang storage cellar in Hejia village, Xi'an, in 1970 (cat. 42).

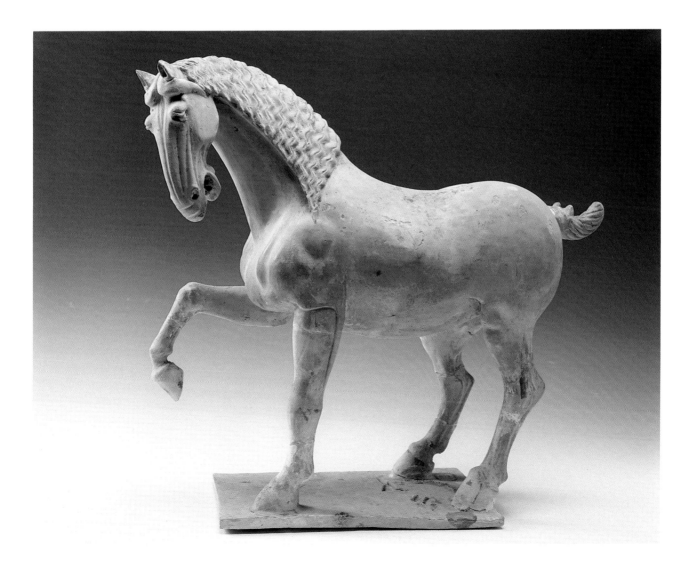

47

Chimera Tomb Guardian with Human Face

Earthenware with greenish white glaze
TANG DYNASTY (618-906)
H: 12³/₁₆ in. (31 cm)
Unearthed from the tomb of Princess Changle in Liquan
 county, 1986
Zhaoling Museum

•

 The practice of placing fantastic creatures in the tomb to
frighten away demons began in the period of the Northern
Dynasties. These fierce guardian beasts often took the form of the
chimera, a half-human, half-animal supernatural being. This Tang
example has the body of an animal and the face of a human with a
pouty expression more childlike than menacing on his chubby face.
He has a conical horn protruding from the top of his head, large
ears, a swelling chest, and front legs extended stiffly to support his
body. The horn, eyes, brows, and mouth are painted with color
pigments while the body is covered with a greenish white glaze.

48

Standing Lady
Earthenware with pinkish pigments
TANG DYNASTY (618-906)
H: 28¾ in. (73 cm)
Unearthed from Hanshen Stockade, Xi'an, 1985
Cultural Relics Bureau, Xi'an

49

Standing Lady
Earthenware with pinkish pigments
TANG DYNASTY (618-906)
H: 32⁵⁄₁₆ in. (82 cm)
Unearthed from Hanshen Stockade, Xi'an, 1985
Cultural Relics Bureau, Xi'an

The slender, elongated bodies that were the distinctive style of the Northern Wei gave way in the early Tang to a new aesthetic which favored a fuller and more rotund physique. It was thought that Yang Guifei, the imperial consort of the Emperor Xuanzong (r. 712-756), may have set the fashion for ladies of ample form. Dressed in elegant clothes with their hair arranged in elaborate coiffures and their faces beautified with cosmetics, the figures of aristocratic Tang women possess a singular sense of grace and charm.

The Tang ideal of feminine beauty is epitomized in these two standing figures. Each wears a long, billowing gown with round collar and loose-fitting sleeves. The hems of their gowns trail on the ground, revealing only the tips of their shoes with cloud-shaped toecaps. One lady raises her right hand and wears her hair in a bun which hangs to one side of her head. The other figure has her hair arranged in a high chignon balanced on the top of her head and folds her hands over her belly. Their robust carriages convey a dignified bearing, representative of patrician ladies of the high Tang period.

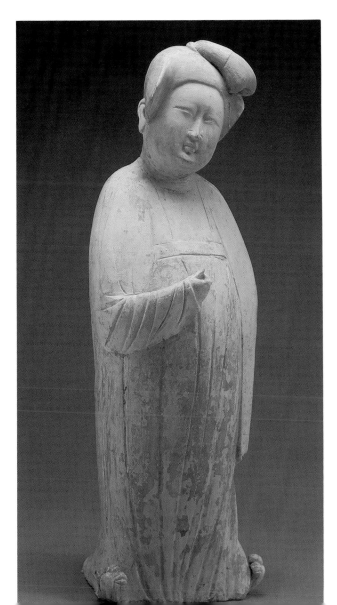

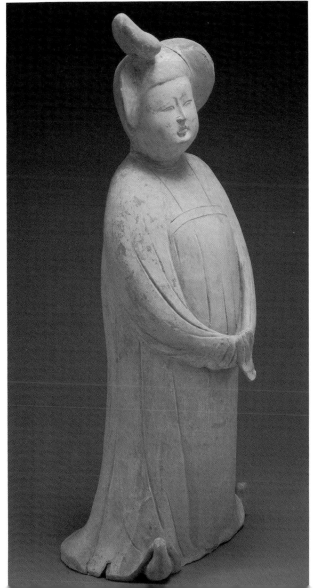

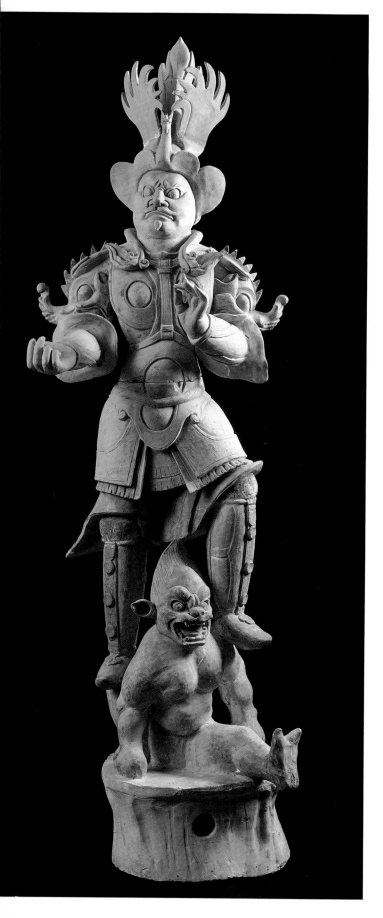

50

Heavenly King Tomb Guardian (TIANWANG)
Earthenware with painted polychrome decoration
TANG DYNASTY (618-906)
H: 50¹³/₁₆ in. (129 cm)
Unearthed from the tomb of Li Zhen, prince of Yue, in Liquan
 county, 1972
Zhaoling Museum

Li Zhen, prince of Yue, was the eighth son of Emperor
Gaozong (r. 649-683), and his tomb is an auxiliary burial to his
father's mausoleum, Zhaoling. Li Zhen opposed the imperial
pretensions of Empress Wu, and after his military defeat in 687
or 688 he committed suicide. In 718, after the Tang dynasty
had been restored, Emperor Xuanzong ordered him reburied at
Zhaoling. More than 130 burial objects were excavated from
the tomb.

The figure of the heavenly king (*tianwang*) tomb
guardian emerged in the mid-seventh century and soon became a
very popular mortuary figure; its development may have been
influenced by the warrior guardians, the *lokapala*, which protected
Buddhist temples. Like the *lokapala*, *tianwang* were outfitted in mil-
itary attire and performed a function similar to that of the guardian
beast or chimera (cat. 47). Both were placed near the entrance of
the tomb to scare off evil spirits, the guardian king paired with a

51

*Heavenly King Tomb Guardian (*TIANWANG*)*
Earthenware with painted polychrome decoration
TANG DYNASTY (618-906)
H: 47⅝ in. (121 cm)
Unearthed from the tomb of Li Zhen, prince of Yue, in Liquan
 county, 1972
Zhaoling Museum

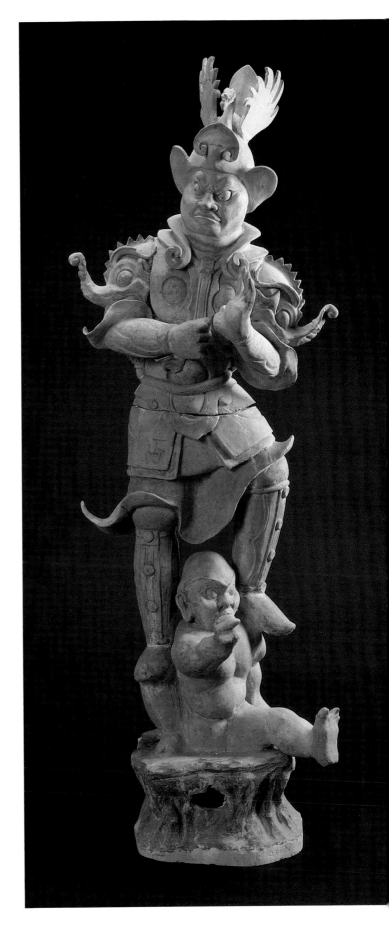

corresponding, but always slightly different, figure and positioned immediately behind the guardian beasts.

 The two guardian kings placed in Li Zhen's tomb are brilliant examples of the technical mastery and skillful imagination of the Tang artisans who created them. The guardian on the left wears an ornate suit of armor fitted with scaly shoulder guards, protective leg coverings, and a pair of high boots with cloud-shaped decoration. He wears an elaborate helmet topped with a pheasant, which extends its head forward and spreads its wings. With his left foot he tramples a grisly little devil with an animal face, human body, and flaming hair. The guardian king on the right wears a similar costume, but tramples a bald demon. The character *gai*, meaning beggar, is written in ink on the lower right corner of his robe. Both guardian figures have large bulging eyes and menacing scowls. Much of the original polychrome pigments on the figures and the gilding on their helmets has worn off.

52

Foreigner on Horseback

Earthenware with painted polychrome decoration
TANG DYNASTY (618-906)
H: 15¼ in. (38.5 cm) L: 13 in. (33 cm)
Unearthed from the tomb of Zheng Rentai in Liquan
county, 1971
Zhaoling Museum

•

The tomb of Zheng Rentai (d. 633), a Left Military Guard General, is located 300 meters southwest of Mazhai village in the town of Yanxia in Liquan county. Like the tomb of Zhang Shigui, it was one of the satellite tombs that accompanied the Tang emperor Taizong's mausoleum, Zhaoling. Fifty-three meters long, north to south, Zheng's tomb is composed of a sloping passage, a courtyard, arched door frames, a corridor, and the coffin chamber. The walls of the passage and the coffin chamber are decorated with mural paintings depicting a procession. The 532 funerary objects recovered from the tomb include primarily glazed polychrome figurines, but also painted polychrome, polychrome and gilt, and stone figurines, as well as ceramic vessels.

Tang *sancai* (three-color) wares were produced from the late seventh century but did not appear in numbers until the reign of the Later Zhou empress Wu (r. 690-705), more than 25 years after the burial of Zheng Rentai in 664. However, ceramics that were both polychromed and glazed, like those found in Zheng's tomb, were probably the predecessors of *sancai*. The superbly painted and gilded figures of the Tang period are often among the largest and most finely modeled tomb sculptures, as is well attested by the mortuary figures in Zheng Rentai's tomb and in the tomb of Li Zhen (cat. 50, 51). Painting with polychrome pigments on the earthenware surface allowed the artisan to delineate intricate details with an accuracy that could not be achieved with *sancai* glazes. The figurines in Zheng's tomb are not only lavishly decorated, they also record the diversity of the cosmopolitan population of Chang'an. As capital of the Tang empire and terminus of the Silk Road, Chang'an was home to people from all corners of the world.

This equestrian figure depicts a foreigner on horseback sitting on a colorfully woven saddle blanket. He is distinguished by his black moustache and thick beard, deep-set eyes and pointed nose, and black turban. The details of both the rider and the horse have been realistically painted in polychrome pigments.

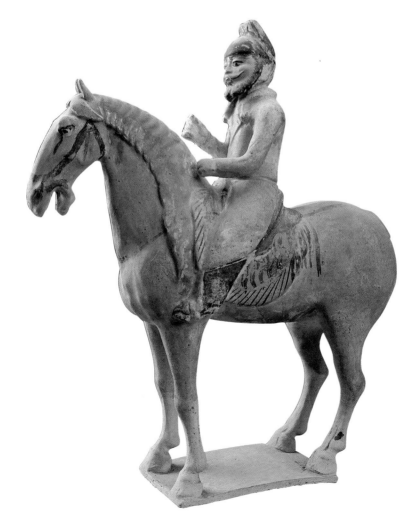

53

Hunter with a Dog on Horseback
Earthenware with three-color (*sancai*) glaze
TANG DYNASTY (618-906)
H: 14⅞ in. (37.8 cm)
Unearthed from the tomb of Princess Yongtai in Qian
 county, 1960
Shaanxi Historical Museum

•

 Figurines fired with *sancai* glazes began to appear in
tombs in the later seventh century. The rich colors and lustrous
glazes suited the taste of the wealthy who increasingly sought to
augment their tomb furnishings with a lavish array of grave goods.
Their popularity was short-lived, however, as the An Lushan rebel-
lion of 756 brought an abrupt end to over a century of extravagant
patronage and the demand for *sancai* tomb figures. Fortunately,
during the fluorescence of *sancai* production, an enormous quantity
of these figures was manufactured for burial purposes, and large
numbers of very fine examples survive.

 This delightful and rare configuration depicts a hunter
wearing a brilliant green robe, green trousers, high leather boots,
and the familiar turban. The robe is slit on the side, allowing the
rider to sit comfortably in the saddle. The horse is a dark russet.
The man, the horse, and the vigilant hunting dog perched on a
pedestal fastened to the back of the saddle are all depicted with a
high degree of naturalism.

54

Figure of a Dancing Black Man
Earthenware with painted polychrome decoration
TANG DYNASTY (618-906)
H: 9⅞ in. (25 cm)
Unearthed from Guo village, Zaoyuanxiang, Changwu
 county, 1985
Changwu Museum

•

According to official documents, the earliest recorded
African kingdom known to China was Shunai, located in the
southern part of present-day Somalia. In 629 Shunai sent a
diplomatic mission to Chang'an. It is believed that Shunai was
one of the tribes the Tang called Kunlun. The term *Kunlun
slaves* referred to black servants, but may also have included
Southeast Asians and other foreigners. During the Tang dynasty,
China engaged in sea trade with Africa from an entrepot at
Canton, where domestic merchandise was traded for products like
ivory and incense. In Africa, in places such as Zanzibar, many
Chinese coins and ceramics have been unearthed.

The Kunlun tribe introduced the "Kunlun dance" to
Chang'an. This figure shows a Kunlun man in native costume as
he performs the spirited dance, his legs bent, his arms raised, and
his body twisted as though responding to the music. Figures of
black men are often found in Tang tombs, but dancing figures are
unusual. He has a mass of curly hair atop a rounded face with large,
round eyes, a wide nose, big lips, and a short, thick neck. The skin
is painted black, and the bright red cloth which barely covers his
shoulders and wraps around below his waist to reach his knees
exposes his chest and belly. Wrist and ankle bracelets and an
elaborate jeweled necklace complete the costume.

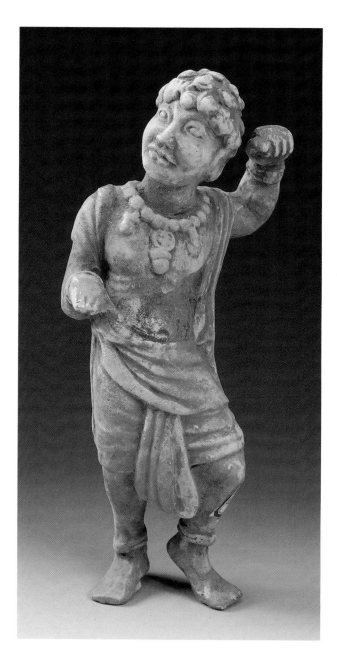

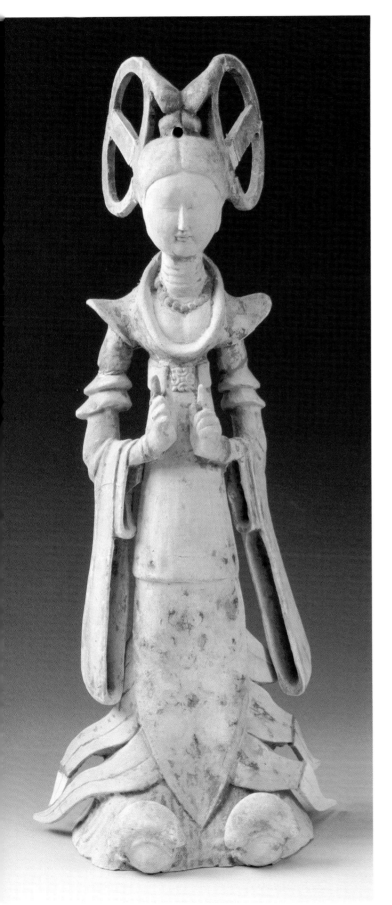

55

Female Dancer with Double Loops of Hair
Earthenware with painted polychrome decoration
TANG DYNASTY (618-906)
H: 14⅞ in. (37.8 cm)
Unearthed from Guo village, Zaoyuanxiang, Changwu
 county, 1985
Changwu Museum

•

 The growing presence of minority groups in Chang'an affected the development of music and dance in the Tang dynasty. Novel cultural ideas in various disciplines had been gradually assimilated by the Chinese since at least the Han dynasty, a process that reached its zenith in the Tang. The ethnic races of Central Asia, India, and Korea were noticeably influential in the areas of music and dance, as Chang'an played host to famous entertainers from many foreign lands. Exotic performances were enjoyed not only by the imperial court but by all sectors of the population. Tomb figures of various types of ethnic performers, such as this figure and the Kunlun dancer (cat. 54), attest to the fact that they were an integral part of metropolitan life in the Tang capital.

 The striking feature of this delicately modeled female dancer is an astonishing coiffure fashioned into enormous double loops of hair. Her perfectly round face, with its "willow-shaped eyebrows and phoenix eyes," complements her tiny, pointed nose, small, painted lips, and long neck. The low collar of her gown exposes milky white skin, and her dancer's costume, with sharply angled shoulders, a cinched waist, and long flowing sleeves, accentuates the slenderness of her body. She also wears a jeweled necklace and a pair of bracelets above each elbow, and her feathered skirt flares out to the sides and trails on the floor above billowy shoes that give the illusion that she is stepping on clouds. Her high-waisted outfit is belted, secured with what appears to be a square carved jade clasp. Her hands are held in front of her body with her slim index fingers pointing up.

56

Female in Male Costume
Earthenware with painted polychrome decoration
TANG DYNASTY (618-906)
H: 12³⁄₁₆ in. (31 cm)
Unearthed from the tomb of Zheng Rentai in Liquan
 county, 1971
Zhaoling Museum

•

The acceptance of various ethnic groups and assimilation of foreign cultures created a very liberal atmosphere in the Tang capital, Chang'an. As traditional strictures regarding the sexes relaxed, women broke free of accepted social customs and behavior. In the Tang capital, women began to dress in men's robes, to put on foreign costumes, to make excursions on horseback, and to participate in sports activities. Examples of Tang women *en vogue* abound in Tang tomb figurines.

This fashionable lady wears a black turban, like the one worn by the foreign equestrian (cat. 52), and a belted brown robe with round collar and tight-fitting sleeves. Underneath her robe she wears a red-and-white striped pair of Persian trousers and pointed blue shoes. Her hands are clasped in front of her chest. Her delicate face is highlighted with long, darkened brows, rouged lips, and two beauty marks. Her demeanor is poised, yet her expression is slightly coquettish. There is no mistaking her femininity despite the male costume. Like much Tang mortuary art, this figure exhibits a naturalistic appearance and a strong sense of individual character.

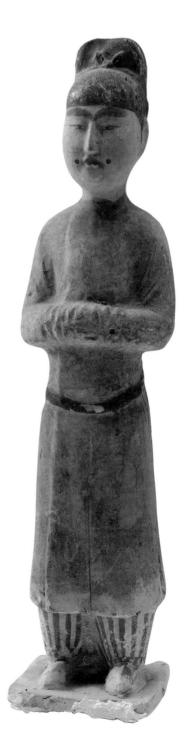

57

Petal-shaped Dish with GUAN *Mark*
Porcelain with white glaze
TANG DYNASTY (618-906)
H: 1⅞ in (4.8 cm) Diam. of mouth: 8⅛ in. (20.7 cm)
Unearthed from Huoshaobi in the northern suburb of
 Xi'an, 1985
Cultural Relics Bureau, Xi'an

•

White porcelain wares appeared in China as early as the period of the Northern Dynasties (late sixth century) and reached a substantial level of production in the seventh century. This more refined field of porcelain production became differentiated from pottery production and eventually spawned an independent handicraft industry. In the Tang dynasty white wares with the *guan* (official) mark produced in the Xing kilns in Hebei province became tribute items for the court. At present, recorded pieces of white wares with this mark number fewer than 70. The hoard at Huoshaobi, in which this piece was included, has yielded 33 pieces of white porcelain marked with the character *guan*. Porcelain wares made of fine clay, with thin walls, a glaze that is pure white or white suffused with green, and a *guan* mark are attributed to the Tang dynasty and Five Dynasties period.

This dish has a shallow body, a low footring, and a rim shaped like six sunflower petals. It is very thinly potted from a fine, pure white paste and displays a rather high vitrification. The green-tinged white glaze is even, glossy, and translucent. In the center of the underside of the dish, the character *guan* is deeply carved. The petal shape of the dish imitates the forms seen in Tang gold and silver objects.

58

Mirror with Wild Geese and Winged Beast Design
Bronze
TANG DYNASTY (618-906)
Diam.: 7⅛ in. (18 cm)
Unearthed from Qian county, Shaanxi province
Shaanxi Historical Museum

•

This intricately decorated mirror has a four-sided boss in the center to correspond with the four quadrants of the pictorial surface. The boundaries are marked by three mountain peaks that simulate the character *shan*, ⊔⊔ (mountain). The scene in each quadrant is identical—two winged beasts fly over a body of water while in the sky three wild geese are encircled by swirling clouds. The background is dense with exotic vegetation. The composition is unusual for the period, perhaps representing some mythical paradise.

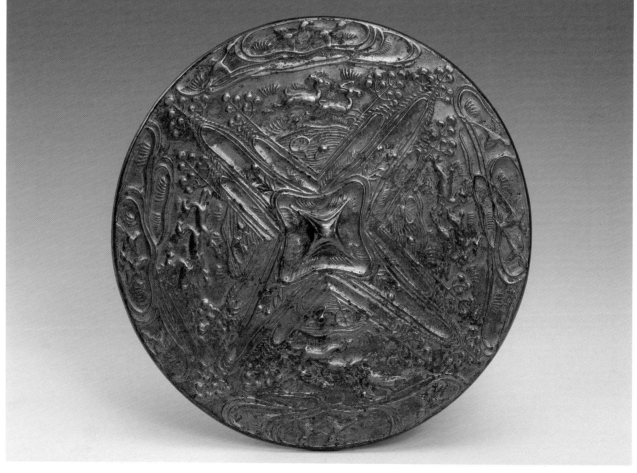

59

Hairpins (3)
Silver
TANG DYNASTY (618-906)
L: 14¹⁵⁄₁₆ in. (38 cm)
Unearthed from Hejia village in the southern suburb of Xi'an
Shaanxi Historical Museum

•

The wealthy and fashionable women of the Tang dynasty adorned themselves with an assortment of exquisite jewelry crafted from precious materials such as gold, silver, pearls, and jade. The elegant hairstyles worn by women of the period were secured with ornamental hairpins. These long, bifurcated hairpins were fashioned out of beaten silver and embellished with openwork finials. The technique is not only ornamental; it reduced the hairpin's weight and allowed it to quiver slightly when the lady moved, creating an effect of shimmering richness. The delicate finials are composed of interwoven floral motifs and are connected to the base by two loops of metal. These ethereal creations were a cherished part of a Chinese woman's wardrobe.

60

Pair of Bracelets
White jade mounted with gold
TANG DYNASTY (618-906)
Interior diam.: 2¾ in. (7 cm) Exterior diam.: 3³⁄₁₆ in. (8.1 cm)
Unearthed from Hejia village in the southern suburb of Xi'an
Shaanxi Historical Museum

•

This pair of bracelets is fashioned from carved pieces of jade and ornamented with gold mounts. Each bracelet is composed of three arcs of white jade, smooth on the interior and carved with grooves on the exterior. The ends of each arc are mounted with gold beaten into the shape of a dragon head and are connected with gold hinges.

61

Jar in the Shape of an Elephant Carrying a Stupa
Earthenware with painted polychrome decoration
TANG DYNASTY (618-906)
H: 23⅝ in. (60 cm)
Unearthed from a pharmaceutical factory in the western
　　suburb of Xi'an, 1966
Shaanxi Historical Museum

•

　　　As both the elephant and the lotus are traditional
Buddhist symbols, this unique jar shows the influence of foreign
religion and artistic motifs on conventional Chinese mortuary
objects. According to Buddhist legend, a white elephant appeared
to the mother of Shakyamuni in a dream as a prophesy that she
would bear a son who would be a great sage. The elephant is also
the vehicle of the bodhisattva of wisdom, Samanthabhadra, who
frequently appears riding an elephant. The lotus is a symbol of the
Buddha himself and of Buddhist purity; consequently, images of the
Buddha often depict him seated on a lotus pedestal. The stupa, a
traditional Indian structure that houses relics of the Buddha,
marks the site of a Buddhist sanctuary. All of these motifs were
introduced to China from India during the Northern Dynasties and
by the Tang dynasty had become fully integrated into the Chinese
artistic vocabulary.

　　　This masterpiece of Tang tomb art may have functioned
as a container for some relic or sacred token belonging to the
deceased. On the back of a majestic elephant rendered in very
realistic detail, right down to the wrinkles of his thick skin, a
stupa-shaped jar is placed on a three-tiered lotus pedestal positioned
on an oval saddle. The stupa resembles its Indian prototype, with
a swelling body and a cover crowned by a series of simplified
umbrellas and topped by a jewel. The body of the jar is decorated
with four elephant heads in relief. Traces of black and vermilion
pigment remain on both the jar and the elephant.

62

Ewer Decorated with Human Faces
Bronze
TANG DYNASTY (618-906)
H: 11⅝ in. (29.5 cm)
Unearthed from the crypt at the base of the Sarira stupa in the
 Tang Qingshan monastery, Lintong county, Shaanxi
 province, 1985
Lintong Museum

•

 One of the most famous monasteries of the Tang
dynasty, the Qingshan monastery, was destroyed during the reign of
the emperor Wuzong (r. 840-846), who instigated an economically
motivated persecution of Buddhism. The ruins of a crypt at the
base of the stupa housing relics of the Buddha (Sanskrit: *sarira*) in
the monastery complex were discovered in May 1985. In addition
to retrieving the now famous Shangfang Sarira Stupa Memorial
Stele, which clearly records the founding of the monastery, workers
unearthed a funeral bier and gold and silver coffins; several *sancai*
objects; an array of gold and silver objects; gilded silver and bronze
vessels; and a bronze ewer with a design of human faces in relief.
These important and rare cultural treasures attest to the prosperity
of Tang Buddhism at its height.

 This unusual bronze ewer has a phoenix-head spout,
dragon handle, and trumpet footring. In the center of the tall,
narrow neck are three raised rings. The distinctive feature, the
six large human heads in high relief, are full and round female
faces with arched eyebrows, large eyes, small mouths, and slender,
pointed noses. The hair is parted in the middle and divided into
three sections that hang to the sides of the face, each set shared
by two heads. The form of this ewer is very unusual and rarely
seen in China. Since the facial characteristics are Indian, this
ewer may be of foreign manufacture, brought to China from India
on the Silk Road.

Selected Bibliography

Akiyama, Terukazu, et al. *Arts of China: Neolithic Cultures to the T'ang Dynasty, Recent Discoveries*. Coordinated by Mary Tregear. Tokyo: Kodansha International, 1968.

Banks, Michael. "Religion and Art in the Northern Wei Dynasty." *Arts of Asia*, vol. 10/no. 4, July-August (1980): 68-74.

——. "Tomb Sculpture of the Northern Wei Dynasty." *Arts of Asia*, vol. 22/no. 4, June-August (1992): 102-110.

Bower, Virginia. "Two Masterworks of Tang Ceramic Sculpture." *Orientations*, vol. 24/no. 6, June (1993): 72-77.

Brussels, Palais des Beaux-Arts. *Trésors d'art de la Chine*. Brussels, 1982.

Capon, Edmund. *Qin Shihuang Terracotta Warriors and Horses*. 2nd ed. Clayton, Victoria: Wilke and Company Limited, 1982.

——. "Chinese Tomb Figures of the Six Dynasties." *Transactions of the Oriental Ceramic Society*, vol. 50 (1975-77): 279-308.

Chang, Kwang-chih. *The Archaeology of Ancient China*. 3rd rev. ed. New Haven: Yale University Press, 1980.

Cotterell, Arthur. *The First Emperor of China*. London and Basingstoke: Macmillan London Limited, 1981.

Lim, Lucy, ed. *Stories from China's Past: Han Dynasty Pictorial Tomb Reliefs and Archaeological Objects from Sichuan Province, People's Republic of China*. San Francisco: The Chinese Culture Center of San Francisco, 1987.

Dien, Albert. "A Study of Early Chinese Armor." *Artibus Asiae*, vol. 43/no. 1/2 (1981-82): 5-67.

Fong, Mary H. "Four Chinese Royal Tombs of the Early Eighth Century." *Artibus Asiae*, vol. 35/no. 4 (1973): 307-334.

Fong, Wen, ed. *The Great Bronze Age of China: An Exhibition from the People's Republic of China*. New York: The Metropolitan Museum of Art/Alfred A. Knopf, 1980.

Juliano, Annette L. *Art of the Six Dynasties*. New York: China House Gallery/China Institute in America, 1975.

——. *Bronze, Clay and Stone: Chinese Art in the C.C. Wang Family Collection*. Seattle: University of Washington Press, 1988.

Kelley, Clarence W. *Chinese Gold and Silver in American Collections: Tang Dynasty A.D. 618-907*. Dayton: The Dayton Art Institute, 1984.

Kesner, Ladislav. "Portrait Aspects and Social Functions of Chinese Tomb Sculpture." *Orientations*, vol. 22/no. 8, August (1991): 33-42.

Klapthor, Frances. *Chinese Ceramics from the Collection of The Baltimore Museum of Art*. Baltimore: The Baltimore Museum of Art, 1993.

Kuwayama, George, ed. *The Great Bronze Age of China: A Symposium*. Los Angeles: Los Angeles County Museum of Art, 1983.

Kwan Pui Ching, ed. *Qiannian gudu Xian* (Xi'an: China's Ancient Capital for a Thousand Years). Hong Kong: The Commercial Press, 1987.

Lefebvre d'Argencé, René-Yvon, ed. *Treasures from the Shanghai Museum: 6,000 Years of Chinese Art*. Shanghai: Shanghai Museum; San Francisco: Asian Art Museum of San Francisco, 1983.

Lewis, Candace J. "Tall Towers of the Han." *Orientations*, vol. 21/no. 8, October (1990): 45-54.

Los Angeles County Museum of Art. *The Quest for Eternity: Chinese Ceramic Sculptures from the People's Republic of China*. San Francisco: Chronicle Books, 1987.

Mackenzie, Colin. "Adaptation and Invention: Chinese Bronzes of the Eastern Zhou and Han Periods." *Orientations*, vol. 24/no. 6, June (1993): 59-68.

The Museum of Qin Terracotta Figures. *Qin Shihuangling bingmayong* (Terracotta Figures at the Qin Shihuang Mausoleum). 3rd printing. Beijing: Cultural Relics Publishing House, 1986.

Museum of Terra-cotta Army of Qin Shihuang. *A Wonder of the World, Treasures of the Nation: Terra-cotta Army of Emperor Qin Shihuang*. Hong Kong: Shaanxi Travel and Tourism Publishing House, 1993.

Qian Hao, Chen Heyi, and Ru Suichu. *Out of China's Earth: Archeological Discoveries in the People's Republic of China*, New York: Harry N. Abrams, Inc.; Beijing: China Pictorial, 1981.

Rawson, Jessica. *Ancient China: Art and Archaeology*. New York: Harper and Row, 1980.

——. *Chinese Ornament: The Lotus and the Dragon*. London: British Museum Publications Limited, 1984.

The Royal Ontario Museum. *Homage to Heaven, Homage to Earth: Chinese Treasures of the Royal Ontario Museum*. Toronto and Buffalo: University of Toronto Press, 1992.

Schafer, Edward H. *The Golden Peaches of Samarkind: A Study of T'ang Exotics*. Berkeley and Los Angeles: University of California Press, 1963.

——. *The Vermillion Bird: T'ang Images of the South*. Berkeley and Los Angeles: University of California Press, 1967.

Schloss, Ezekiel. *Ancient Chinese Ceramic Sculpture: From Han through T'ang*. 2 vols. Stamford, Connecticut: Castle Publishing Co., 1977.

——. *Art of the Han*. New York: China House Gallery/China Institute in America, 1979.

Sickman, Lawrence, and Alexander Soper. *The Art and Architecture of China*. Harmondsworth, Middlesex: Penguin Books, 1956.

The Silk Road, Treasures of Tang China. Singapore: The Empress Place, 1991.

Steinhardt, Nancy Shatzman. *Chinese Imperial City Planning*. Honolulu: University of Hawaii Press, 1990.

Sui Tang wenhua (The Culture of the Sui and Tang Dynasties). Hong Kong: China Publishing House Co., Ltd., 1990.

Treasures from Chang'an, Capital of the Silk Road. Hong Kong: Hong Kong Museum of Art, 1993.

Wang Xueli, ed. *Zhongguo Han Yangling caiyong* (The Colored Figurines in Yangling Mausoleum of Han in China). Hong Kong: Shaanxi Travel and Tourism Press, 1992.

Watt, James C. Y. *The Arts of Ancient China. The Metropolitan Museum of Art Bulletin*, Summer (1990).

Werner, E. T. C. *Myths and Legends of China*. 5th reprint. London: George G. Harrap & Co., Ltd., 1958.

Wong, Grace, ed. *Treasures of the Han*. Singapore: The Empress Place, 1990.

Xiao Tong. *Wen xuan* (Selections of Refined Literature). David R. Knechtges, translator. Princeton: Princeton University Press: 1982.

Yin Shengping and Li Xixing, eds. *Shaanxi History Museum: Selected Treasures*. Hong Kong: Educational and Cultural Press Ltd., 1992.